FAIRFIELD
COUNTY
SOUTH CAROLINA

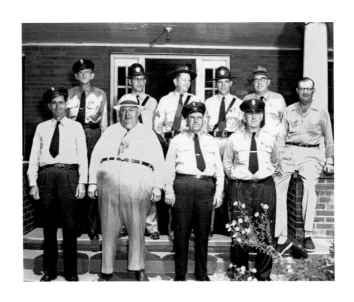

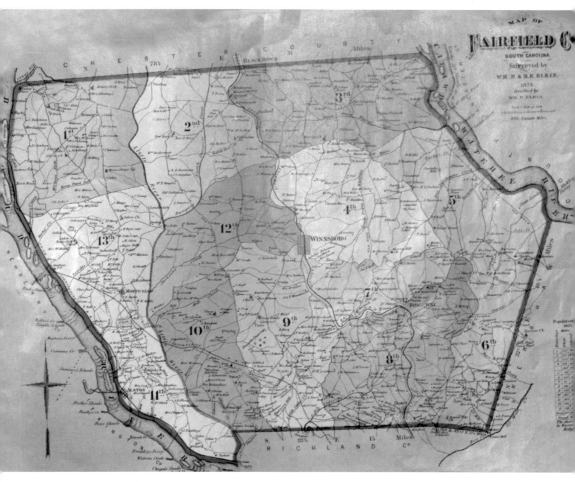

Map of Fairfield County
Counties in the northern portion of South Carolina were redistributed and specifically governed numerous times over the years. In 1785, the area became districts and Fairfield County was part of the Camden District. After the American Revolution, new counties were again defined. Except for a few towns on the county border, such as Blythewood, which was annexed into Richland County, the Fairfield County map has remained relatively the same for the last 150 years. (Courtesy of the Fairfield County Historical Museum.)

Page 1: Law Enforcement
Pictured are Fairfield County law enforcement officers in the 1940s. (Courtesy of the Fairfield County Historical Museum.)

LEGENDARY LOCALS

OF

FAIRFIELD
COUNTY
SOUTH CAROLINA

VIRGINIA SCHAFER
FOREWORD BY PELHAM LYLES

LEGENDARY
LOCALS

Dedication
I am honored to dedicate this brief pictorial history to the people of Fairfield County. I also want to especially honor the military heroes of yesterday and today. Freedom is the fundamental condition that defines our history. Thank you, Fairfield County. This is an experience that has changed my life.

On the Cover: From left to right:
(TOP ROW) Miriam Stevenson, Miss Universe (Courtesy of the Fairfield County Historical Museum; see page 89); Doug Ruff, proprietor of Ruff Museum (Courtesy of Virginia Schafer; see page 21); Drink Small, blues guitarist (Courtesy of Virginia Schafer; see page 110); Maj. Thomas Woodward, South Carolina statesman (Courtesy of the Fairfield County Historical Museum; see page 14); Charlotte Dunlap, missionary (Courtesy of the Fairfield County Historical Museum; see page 41).
(MIDDLE ROW) Kelly Miller, South Carolina educator (Courtesy of Virginia Schafer; see page 49); Joseph and Frances McCreight, military hero and leader (Courtesy of the Fairfield County Historical Museum; see page 16); Tommy Sprott, musician and politician (Courtesy of the Fairfield County Historical Museum; see page 112); James F. Byrnes and Miriam Stevenson, governor of South Carolina and Miss Universe (Courtesy of the Fairfield County Historical Museum; see page 89); Ronnie Collins, athlete (Courtesy of the Fairfield County Historical Museum; see page 102).
(BOTTOM ROW) Emily Obear, teacher (Courtesy of the Fairfield County Historical Museum; see page 40); John Johnson, athlete (Courtesy of the Fairfield County Historical Museum; see page 98); Herman Young, sheriff (Courtesy of Fairfield County Sheriff's Department, see page 88); Sabe Cathcart, farmer (Courtesy of the Fairfield County Historical Museum; see page 54); Susan Douglass Taylor, musician (Courtesy of Virginia Schafer, see page 111).

CONTENTS

FOREWORD

It is with pride that I write these words of gratitude for Virginia Schafer's presentation of this book. She has partnered with the Fairfield County Historical Museum's mission to identify and preserve the stories and artifacts of our community life. Until now, public documentation in print depicting Fairfield County's bountiful history has only minimally covered the 275-plus years of its existence. Fitzhugh McMaster, William Edrington, Phillip Pearson, Jack Meyer, and Robert Mills have given us glimpses into the first 150 years of our cultural development in text, and laudable collections of old photographs and family stories have been published by Faye Johnson and Crosby and Beverly Rice in recent decades. Virginia, thank you for coming to our town and reminding us of who we are!

Our complete story, neglected so long, can never be gathered and recreated in such a way that would approximate the fabled "time machine" we all would love to step into. However, Virginia's efforts to collect the stories depicted in these images should be viewed as equivalent to the actions of an old-time itinerant photographer's snapshot capturing a sliver here and a sliver there of Fairfield goings-on.

We must assist these efforts to provide further proof of our past. There are still unidentified images in the museum collection and untold numbers of undiscovered photo albums in peoples' attics and dusty shelves. Hopefully, this small glimpse of some of our community's stories will rout out the collectors among us who realize the importance of sharing the contents of their family's treasure troves.

Too often, we chat after a funeral and express regrets for not having listened better to the deceased's stories or asked for explanations of family pictures. The tales and images gathered here in a short time by our friend Virginia should prompt more of us to identify the unidentified before another generation inherits the puzzle of establishing their importance to our personal and community heritage.

—Pelham Lyles

ACKNOWLEDGMENTS

I could not have done this project without the resources at the Fairfield Historical Museum. Pelham Lyles is a wealth of knowledge about her historical family and the history of Fairfield County. If Pelham did not know the answer, she had a never-ending Rolodex of contacts and resources. Thank you, Shelbia Trotter, for your insight to the history of the Fairfield Mill and for helping me organize and identify the photographs. I also want to thank my new friends Jan Albriton, Amy Douglas, Liz Foreman, and the other 600-plus Winnsboro Facebook friends. They were invaluable with their identification of the unnamed photographs and they gave me great insight with their stories and conversation. Special thanks goes to my old friend Rev. Carroll Pope, who was my inspiration to do this book. Of course, I cannot leave out the South Carolina Writers Workshop, and my close friends in the Cola III Chapter. Unless otherwise noted, all images appear courtesy of the Fairfield County Historical Museum.

INTRODUCTION

In earlier times, when lord proprietors ruled the provinces of the Carolinas, Fairfield County was part of Craven County. Fairfield County lies in the middle of South Carolina, between the Upstate and Lowcountry. Although still north of what is known as the Midlands, Fairfield County is a unique mix of people with different cultures, traditions, and history. Some of the population influx had followed trails from the North, particularly from Pennsylvania, Virginia, and North Carolina. Many of these were the Scotch-Irish who came to the area seeking religious freedom, farming opportunities, and community living. Other folks came from the seaside regions through the coastal areas, such as Charleston. These people were British, German, Jewish, and French Huguenot and were generally educated, cultured, and financially secure. The combination of these people melded into a rare breed. They were brave and stubborn, sometimes refined and elegant, religious and proud, industrious and hardworking, and educated and aristocratic. They also fought hard to build and protect their homes in the underdeveloped wilderness.

The first inhabitants in this area were Indians. The Cherokees, Catawba, Shawnee, Iroquois, and even Natchez tribes roamed northern South Carolina. In 1566, the European explorers conquered this part of the South, and soon came a major immigration of the British, the planters, the soldiers, and farmers. This was a concern to the Native American tribes, who were allied with the French and Spanish. Although the Indians were mostly anti-British and anti-American, the leaders did try to work out their differences through treaties. The Native Americans desired to communicate with the governor and even the King of England to make peace with the new invaders. Chief Shote, of the Cherokee Indian Nation, accompanied the humanitarian colonial officer and journalist Henry Timberlake to London to make a plea on behalf of the Native Americans in the South. It was a futile attempt for equality. Timberlake's published memoirs of living with the Cherokees later became the anthropological and historical text for this subject. Unfortunately, Timberlake was incarcerated for nonpayment of these trip expenses and died at age 36.

In the meantime, the British had a new plan for this area of South Carolina. Their strategy was to form a human barrier between the Indians and the new successful plantation owners in the Midlands and coastal regions. Land grants of 200 acres for each man and 100 acres for each woman and child were offered to families willing to relocate to Craven County. Many European farmers came hoping for a new beginning, clueless about the possible conflicts. The new population not only suffered from Indian attacks, but many also perished in the unforgiving wilderness. In addition, the newcomers faced conflicts from within and, eventually, with their host, the British. Battles were on the horizon.

About 1760, the time of the French and Indian War, forts were built. These remotely settled inhabitants wanted to protect their families and possessions. Their foods and needs came mostly from the surrounding forest and rivers or on packhorses from the Congaree River. Land protection and the building of prudent relationships with the local Native Americans were important. These colonists fought day after day just to survive.

After the Cherokee Wars, the settlers faced new threats: bandits and thieves. Regulators or "self-appointed lawmen," took it upon themselves to keep peace and handle troublemakers. Two of the most noted were Moses Kirkland and Thomas Woodward. They were known as Godly, courageous, and honest men. Many of these same men would continue to fight during the British conflict and the Revolutionary War.

There were struggles from within the population, especially during the early times of the British occupation. Loyalists like Col. John Phillips, a friend of Gen. Lord Charles Cornwallis, befriended Gen. Richard Winn, a transplant from Virginia. He was a great facilitator. Richard Winn along with his brother John surveyed and created the village of Winnsborough. General Winn became a state legislator, merchant, and land surveyor and an important part of Fairfield County history.

As always, the settlers of Fairfield were ready to fight for their homeland. Many served proudly in the Civil War. Men usually joined a regiment or company that originated in their community. The area surrounding Fairfield County, especially around the Wateree River, was struck hard by the firebrands of Union army stragglers in early 1865. These supply scavengers came down the waterways and roads and captured food stores, textiles, money, and jewelry from local homes and businesses. The bandits often torched what was left, leaving the locals in dire straits. Due to the location of a telegraph office in Ridgeway, Gen. Pierre Beauregard, the commanding general of the division of the west during the Civil War, set up temporary headquarters in the old brick building called the Century House, which still stands today. Many landmarks, as well as a wealth of natural resources, were targets during the Civil War for General Sherman's march of destruction.

What came from these ashes of ruin were the generations of survivors, fighters, and proud protectors. Many young men attended Winnsboro's Mount Zion Institute, one of the most prestigious boys' preparatory schools in South Carolina at that time. These graduates went onto the South Carolina College in Columbia or to the Citadel, South Carolina's premier military college, in Charleston. Many forged their mark and worked as engineers, like Col. David DuBose Gaillard who helped build the Panama Canal, or freedom fighters, such as William Oscar Brice, a four-star general who was a decorated mentor in World War II. Sgt. Webster Anderson embodied the courage of Fairfield County's countless military heroes. A Medal of Honor recipient, Anderson sacrificed one arm and both of his legs for his country during the Vietnam conflict. Then, there was William Belk, at the wrong place at the wrong time, who was kidnapped during the Iran Hostage Crisis. For the most part, these brave folks came home to Fairfield County to live, work, and play. Fairfield County's trailblazers willingly fought to protect their home and cherished the importance of family and heritage.

As important as their heritage, many immigrants came to this area to preserve their culture and values. Many wanted to worship freely. Churches and religious organizations became the backbone for the county. The Seventh-day Adventist groups started as early as 1740–1750. An Episcopalian priest organized the meetinghouse, and in the late 1700s, the Presbyterians came to Ridgeway. In 1762, Jacob Gibson, a Baptist minister, is thought to have started the first school while John Nicholas Martin brought in many Lutherans from Germany. The Feasters, originally Dunkards, began the Liberty Universalist Church, and the Reformed Synod of the Carolinas was organized at the Brick Church. The Latter-day Saints of Jesus Christ (Mormons) came to Fairfield County in the mid-1800s. South Carolina was the birthplace of Reform Judaism in the Americas and was the first place in the Western world to elect a Jewish person to a public office. The combination of religion and education was a power that no one could take away from these resilient early settlers.

The proud folks of this community worked hard whether it was in the cotton fields or in the mill or at the granite quarry or on the railroad. Fairfield County survived because of its people. Some went on to become lawmen and politicians, people who made changes or just upheld the law and kept the people safe. Fairfieldians supported growth by providing businesses, such as gas stations, retail stores, banks, and factories.

The people, even though diversified in religion and cultures, played hard too. They held dances, beauty contests, and fundraisers. These folks formed social clubs, associations, and organizations to help others in the community. Many events focused on raising money or gifts for a good cause. Festivals and holidays brought parades and social events. People shared food, music, and fun. The celebration of arts and culture runs deep in this county, with numerous art and music happenings still occurring throughout the year. Catharine Ladd, the founder of one of the finest girls' schools in the state in the mid-1800s, took it upon herself to bring "gaiety" into the hearts of the citizens of Fairfield County during some of the darkest days of the Civil War. She taught art and music to young ladies. Kitty Rion penned and illustrated native

flowers and gardens. Laura Glenn Douglas and Russell Henderson celebrated Fairfield County in their art. Music was celebrated through local harmonies of folk, hillbilly, jazz, and African blues.

Lastly, Fairfield County, like many other historic places, comes with its share of legends and stories. A soldier is blinded, but who did this heinous crime? Some say that this racial confrontation sparked the civil rights movement of the 1960s. Songs and movies were written as a tribute to this soldier. During the 1940s, an illegal basketball game was played in secrecy between white students at Duke University School of Medicine and North Carolina College for Negroes. Did a Fairfield educator play in that game? Other legends include a deathbed confession about the true identity of the Lost Dauphin, and the whereabouts of a set of conjoined twins who once sang to the queen of England. Were they possibly hidden in Ridgeway? Do the great-grandchildren of the original "Siamese twins" live in Fairfield County? That is a good possibility considering the Bunker twins, joined at the chest, owned a farm not so far away in North Carolina, and they had 21 children between them. Did a courageous cowboy from Fairfield County single-handedly fight off at least 10 vicious bandits? Was a famous British officer buried in a bottle of rum in a Fairfield County pub, and does the mummified ghost of Colonel Provence still haunt his desecrated gravesite? Did the largest moonshine bust in Fairfield County happen in the 1920s, 1930, or 2012? A tough question, considering the fact that Fairfield County was one of the top moonshine manufacturers in South Carolina. Here in Fairfield County, the fields and stories are richer than anyone can imagine.

CHAPTER ONE

Early Settlers

First the Indians and then the Europeans and other pilgrims inhabited the area. Plantations and farming were mainstays of South Carolina. Then, in the early 1700s, the commonwealth's land grant strategy brought to Fairfield County a major immigration of farmers and businessmen looking for new lives. The settlers faced many challenges, including the defensive American Indians. These Scotch-Irish, German, French Huguenot, and British settlers were unaware and untrained for the obstacles in this unforgiving environment. Challenges later included bandits, pirates of the wilderness. Eventually, the enemies also included the British. These pioneers had to be strong, tough, brave, and stubborn to survive. Some warriors and military men, such as Col. Ephraim Lyles, settled in the western part of Fairfield County. They came down from the North via the Great Wagon Trail and settled near the Broad River. At that time, this was one of the main populated areas of the county. Colonel Lyles's grandson Col. Thomas Lyles married into the Peay family, who were other early settlers and plantation owners. Other families in this area included the Blairs, Crowders, Faucettes, Mobleys, Stevensons, Brices, and Colemans.

The Winn family obtained land grants from the king and developed the charter to start the township of Winnsborough, later called Winnsboro. This community was located in a strategic area between the Wateree and Broad Rivers. Because of its close proximity to Charleston and Charlotte, it was a great midpoint for business and transportation. The new settlers took advantage of the fertile land and the mild temperature, which were perfect for farming. The town prospered, and progressive religious organizations, politics, and education were the focus. Banks and retail business took over the downtown Congress Street area. The railroad was the active mode of transportation. Many early settlers included the Cathcarts, McCreights, Rions, McMasters, Buchanans, McCants, and MacFies.

Cotton was king in South Carolina, and many plantation owners and farmers flocked to the area. Pioneers began coming to the area of Lebanon in the 1740s. These were hard working and thrifty leaders that included families such as the Buchanans, Martins, Phillips, Turners, and Popes.

Many Presbyterians, such as the Palmers of Charleston, settled in the area south of Winnsboro now called Ridgeway and Longtown. Other family connections included the Thomases, Gaillards, DuBoses, Ruffs, Browns, Carlisles, and Brooms. Jews also came to South Carolina to avoid religious persecution and to worship freely. They came to the South to become merchants, bankers, and businessmen. Jewish families, such as the Wolfes, Cohens, and Baruchs, were instrumental in not only businesses but also fields of medicine, finances, and politics, the arts, and environmental preservation. Many churches and stores serviced the growing community. Politicians, lawyers, bankers, and doctors were needed in the growing communities, especially after Reconstruction. The South was rebuilding in many ways, and the population was increasing. The early settlers propelled Fairfield County into the next era of progress.

Chief Cunne Shote

Chief Shote succeeded his uncle Kanagatucko (Old Hop) as chief of the Cherokee Indian nation in 1760. He was a very important leader, especially in the colony of South Carolina during the war against Britain. Shote, also known as "Standing Turkey" or "Kungadoga," was pro-French and led the war against the British. The aftermath brought destruction to the Cherokees, including the murder of many of the leaders who were held hostage at Fort Prince George (located in what is now Pickens County). The Cherokees were both friend and foe in Craven County, South Carolina. This image of Chief Cunne Shote is a reproduction of the famous painting done by artist Francis Parsons before the chief's visit to the King of England to ask for Indian rights. (Author's collection.)

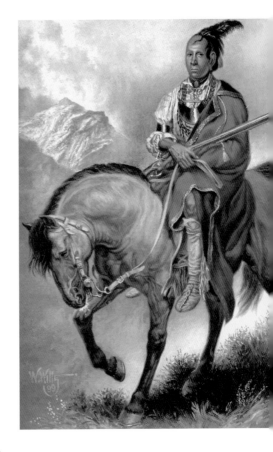

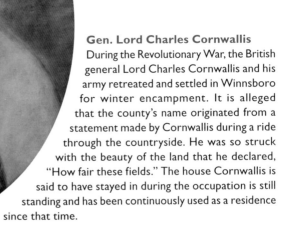

Gen. Lord Charles Cornwallis

During the Revolutionary War, the British general Lord Charles Cornwallis and his army retreated and settled in Winnsboro for winter encampment. It is alleged that the county's name originated from a statement made by Cornwallis during a ride through the countryside. He was so struck with the beauty of the land that he declared, "How fair these fields." The house Cornwallis is said to have stayed in during the occupation is still standing and has been continuously used as a residence since that time.

Cornwallis Camped Here
In 1929, a stone monument was erected on the grounds of the Mount Zion Institute. This was the exact location where Gen. Lord Charles Cornwallis camped during his winter of discontent in 1780. The Richard Winn Chapter of the Daughters of the American Revolution erected this monument. (Author's collection.)

Wade Hampton III (1818–1902)
Hampton was a South Carolina soldier and governor, and he served two terms as a US senator. He also was one of the wealthiest plantation owners in South Carolina. As chief of the cavalry for the Confederate army, he ordered General Beauregard, in Ridgeway, to bottle up General Sherman's army at the river. However, the general refused to execute the order, and the war continued until 1865, when General Sherman had destroyed much of the South.

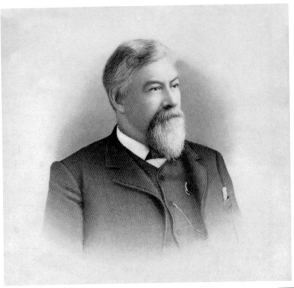

Maj. Thomas W. Woodward
Woodward, a relation to the Lyles family, was a major in the 6th South Carolina Volunteer Regiment during the Civil War and went on to fill many important offices during the Reconstruction era. Major Woodward served as a South Carolina senator and was a delegate to the 1872 National Democratic Convention. He was the great-grandson of famous Revolutionary War hero and Regulator Thomas Woodward, who was also a member of the first Provincial Congress of the United States.

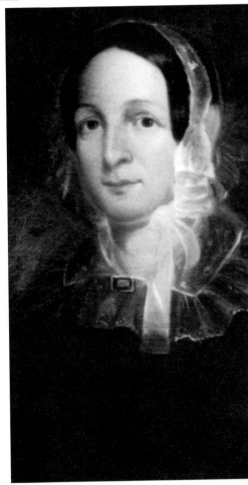

Harriett Winn Shannon
Harriett was the daughter of Minor Winn and Mary Evans Winn. Mary Evans was the sister of the famous politician David Reid Evans of Winnsboro, and Harriet was his favorite niece. The Winns—Richard, Minor, and John—were one of the largest landholders in the county and also the gentlemen who helped the area progress with land sales and development. Winnsboro was named for these men, who were the first to draw up the city charter. The brothers were considered a threat to Gen. Lord Charles Cornwallis and were imprisoned and condemned to the gallows. However, the Winns still had many political allies who saw to it that they were released unharmed. At a young age, Harriett Winn married a gentlemen in Mississippi but returned to Fairfield County and married Charles John Shannon. Shannon started out as an educator in the Orphan Society School, then, with good partnerships, went into the mercantile business. Shannon became a very successful businessman, plantation owner, and president of the local bank. He provided a nice house and living for his family. Shannon's first wife had died during her 10th pregnancy; she was rumored to have been carrying triplets. Harriett and Shannon had been friends over the years and thus married when his first wife passed away. As the new Mrs. Shannon, Harriett was active in many enterprises and social functions as a banker's wife and the daughter of a prominent family. The Shannons (and Winns) were some of the wealthiest families in the area in the mid-1800s.

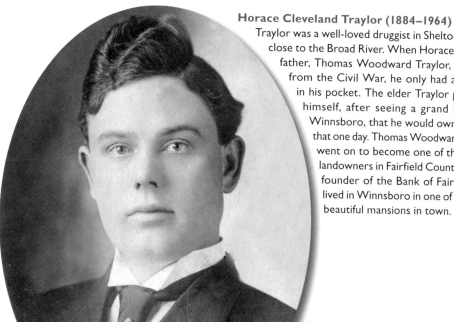

Horace Cleveland Traylor (1884–1964)

Traylor was a well-loved druggist in Shelton, an area close to the Broad River. When Horace Traylor's father, Thomas Woodward Traylor, returned from the Civil War, he only had a quarter in his pocket. The elder Traylor promised himself, after seeing a grand house in Winnsboro, that he would own one like that one day. Thomas Woodward Traylor went on to become one of the largest landowners in Fairfield County and the founder of the Bank of Fairfield. He lived in Winnsboro in one of the most beautiful mansions in town.

Thomas Minter Lyles Jr. (1811–1902)

Thomas Minter Lyles Jr., son of Maj. Thomas Lyles of the 6th Brigade and of the South Carolina Legislature, was a war hero and plantation owner. Thomas Jr. moved into his father's plantation, Ivy Hall, and had one of the finest houses and plantations in the South. As lieutenant colonel of the militia, Lyles proudly served in the Civil War, as did five of his sons. Unfortunately, two were killed. Many of the citizens of Fairfield County are related to the Lyles family.

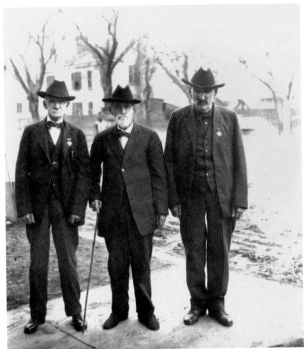

Joseph Wilson McCreight (1842–1928)

McCreight (far left) was the great-great-grandson of William McCreight Sr., who built the first clapboard house in Winnsboro. McCreight joined the Boyce Guards of the 6th Regiment of the South Carolina Volunteers at the age of 19. In the Battle of Seven Pines, young McCreight was one of the few surviving members of the regiment, though he was severely wounded. After the Civil War, he was a member of the Odd Fellows and the paramilitary group called the Red Shirts. McCreight was a dynamic politician and businessman.

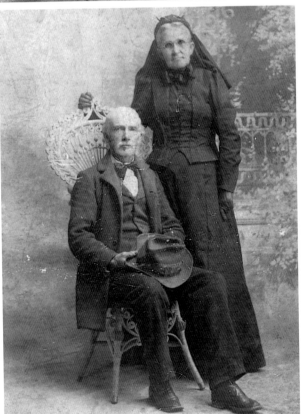

Joseph and Frances McCreight

Joseph McCreight married Frances "Fanny" Armenthie Milling, daughter of John Milling, and went into his family's construction business after the war. He also worked as a jailer, deputy sheriff, and postmaster for the Senate and House. Joseph and Fanny had six children.

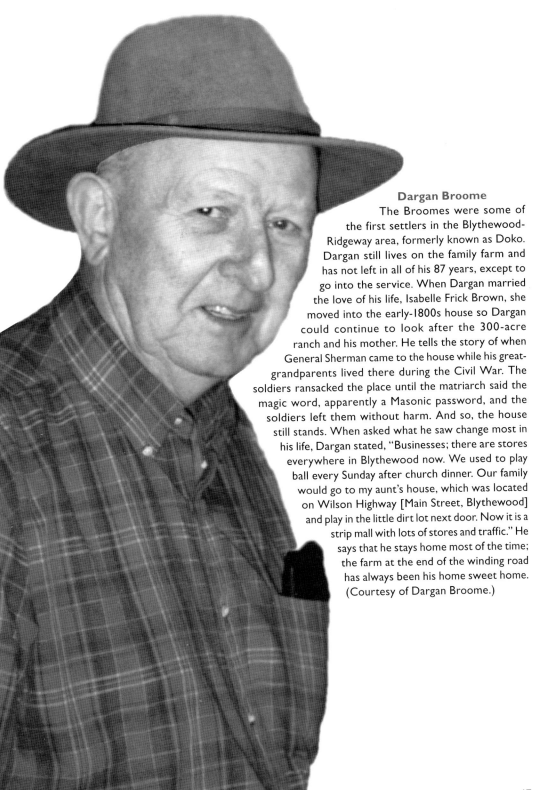

Dargan Broome

The Broomes were some of the first settlers in the Blythewood-Ridgeway area, formerly known as Doko. Dargan still lives on the family farm and has not left in all of his 87 years, except to go into the service. When Dargan married the love of his life, Isabelle Frick Brown, she moved into the early-1800s house so Dargan could continue to look after the 300-acre ranch and his mother. He tells the story of when General Sherman came to the house while his great-grandparents lived there during the Civil War. The soldiers ransacked the place until the matriarch said the magic word, apparently a Masonic password, and the soldiers left them without harm. And so, the house still stands. When asked what he saw change most in his life, Dargan stated, "Businesses; there are stores everywhere in Blythewood now. We used to play ball every Sunday after church dinner. Our family would go to my aunt's house, which was located on Wilson Highway [Main Street, Blythewood] and play in the little dirt lot next door. Now it is a strip mall with lots of stores and traffic." He says that he stays home most of the time; the farm at the end of the winding road has always been his home sweet home. (Courtesy of Dargan Broome.)

Mary Sue Lever Leitner

Mary Sue Lever was one of seven children born to Dr. John D.F. and Nancy Smith Lever. Dr. Lever, the legendary physician of the 1800s in Fairfield County, was known for his fine education and often-high prices. He furthered his studies by dissecting the bodies of deceased slaves to document anatomical features. His daughter married fellow Little Cedar Creek settler William Jefferson Leitner. Their famous lineage includes Sen. Benjamin Hornsby Sr. and Benjamin Hornsby Jr., former director of the South Carolina Archives. In this picture, Mary Sue Lever Leitner is holding her granddaughter Esther Leitner (Hornsby). The other young girl is unidentified. (Courtesy of Benjamin Hornsby Jr.)

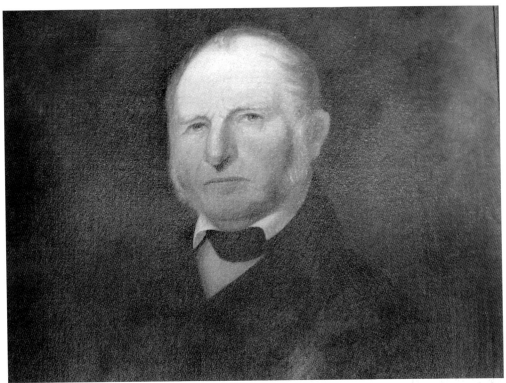

John Feaster (1768–1848)

The community of Feasterville was named for John Feaster. Feaster (originally "Pfister") was a successful farmer and businessman. He and other community members donated and built the Liberty Universalist Church and eventually a schoolhouse. The Feasters, part of the Old German Baptist Brethren (OGBB), worshipped under the Universalist movement, a hybrid form the OGBB started in the Northeast in early 1700.

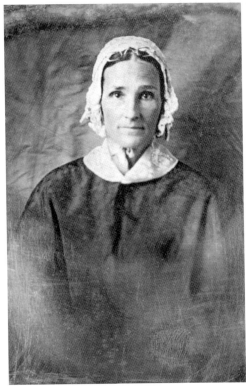

Drusilla Mobley Feaster (1770–1807)

Drusilla, daughter of Samuel Mobley and Mary Wagner, married John Feaster in 1786. They had seven children; sadly, Drusilla died when her last child was born. John's parents pitched in to help raise the children. John had built the little village of Feasterville, and Drusilla helped manage the properties until her death. These properties included a church, schoolhouse, boardinghouse, a grand home, and a family cemetery. The Feasters had 67 grandchildren.

The Colemans

Andrew McConnell, an Irish immigrant, came to Fairfield County to be a rich man. He had heard about the green pastures and rich farmland and set upon a life in the western portion, later known as Feasterville. McConnell did become one of the richest men in the county and, by middle age, was known as one of the most successful men of the Southern dynasty. McConnell bought one of the finest plantations in the area from James F.V. Legg. McConnell owned thousands of acres and more than 100 slaves when his first wife died, leaving him with several small children. Thus, the busy planter and mature man of over 50 years old needed a mother for his children. He set his sights on a much younger wife, Malinda Dickerson. Some said it was love at first sight; others said it was a marriage of convenience. "Lin," as her family called her, was in a field picking cotton when McConnell formally introduced himself. He was dressed in fine clothes and was sitting upon one of the most valued horses in the county. McConnell then called on Malinda's father and gave him a gift, a pair of fine leather gloves. McConnell and Malinda were soon married. The bride was 19 and had one child with McConnell, a boy named Benjamin. The son was only eight years old when his father died, and soon after, Malinda married the plantation's previous owner, James "Old Jim" F.V. Legg. Pictured is Andrew Mac McConnell Coleman, son of Andrew McConnell's daughter Mary, who married Dr. Robert William Coleman, an influential citizen in Fairfield County. Mac married Annie Feaster, also pictured, the daughter of Virginia Rawls and David Feaster, one of the earliest settlers.

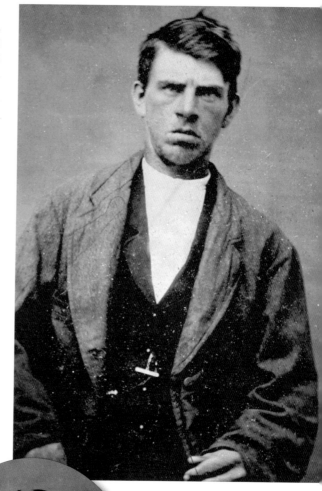

Doug Ruff
One of the first commercial buildings in Ridgeway was Ruff & Co. Mercantile. In the mid-1800s, lower Fairfield County was a haven for industry and progress after the railroad and telegraph line came to the area. The business has remained in the Ruff family since that time. The original hardware store is now the Ruff Museum, and the present-day hardware store was added on to the original Ruff & Co. Mercantile building. Pictured here is Doug Ruff, the son of John Ruff, who owns a custom-made furniture store across the street. (Author's collection.)

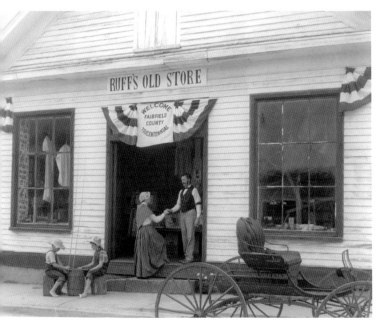

Ruff & Co. Mercantile
Ruff & Co. Mercantile, though it has changed locations and is presently next door to the Ruff Museum, has been in business since 1840. David Ruff is a seventh-generation owner of the store, where he and his wife, Karen, carry on the sale of unique and necessary goods. The Ruff family has been a driving force in the community since the 1800s.

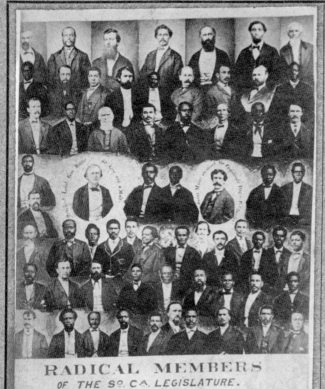

RADICAL MEMBERS
OF THE S°. C^. LEGISLATURE.

PHOTO. COPY BY HOWARD. WASHINGTON. D. C.

NAMES.
READING FROM LEFT TO RIGHT

Line 1.—Dusenberry, *white*, Mc-
Kinlay, *colored*, Dickson, w,
Wilder, c, Hoyt, w, Randolph,
c, Harris, c.

Line 2.—Mayes, c, Jillson, w,
Lomax, c, Jackson, w, Thomas,
c, Webb, w, Bozeman, c, Tom-
linson, w, Wright, c.

Line 3.—Demars, c, Brodie, c,
Hayes, c, Cain, c, Maxwell, c,
Martin, w, Cook, c, Miller, c.

Line 4.—Rivers, c, Duncan, c,
Boozer, w, Smythe, c, Wright,
c, Moses, w, Sanders, c,
Nuckles c.

Line 5.—Miteford, w, White, c,
Barton, c, Boston, c, Shrews-
bury, c, Mickery, c, Henderson,
c, Howell, c, Hayne, c, Mobley,
c, Hudson, c, Nash, c, Car-
mand, c.

Line 6.—Smith, c, Pettengill, w,
Hyde,—, Lee, c, Simonds, c,
Chestnut, c, McDaniel, c,
Williams, c, Gardner, c.

Line 7.—Swails, c, Perrin, c,
James, c, Johnston, c, Wim-
bush, c, Hayes, c, Farr, c,
Meade, c, Thompson, c,
Rainey, c.

These are the photographs of 63 members of the reconstructed South Carolina Legislature, 50 of whom are negroes or mulattoes and 13 white.

22 read and write (8 grammatically) the remainder (41) make their mark with the aid of an amanuensis. Nineteen (19) are tax-payers to an aggregate amount of $146.10, the rest (44) pay no taxes, and the body levies on the white people of the State for $4,000,000.

John Woodward Lyles (1845–1933)
John Lyles (right) was a direct descendant of one of the earliest settlers in Fairfield County. At 16, he volunteered in the Confederate army and was assigned to the Angus P. Brown Cavalry. Lyles served as Fairfield County clerk of court for 28 years. He fought for the farmers' alliance, often making enemies, but continued to be a powerful personality until his death at age 88. (Courtesy of Pelham Lyles.)

Radical Members of the Reconstructed South Carolina Legislation (OPPOSITE PAGE)
In 1867, the federal government implemented the Reconstruction Acts. According to the order, in South Carolina, newly freed slaves now had the right to vote, which created a majority of blacks in the new state legislature's lower house. This "black-and-tan" convention created a new constitution for South Carolina that was quickly ratified and provided a successful request to be readmitted to the Union, which took place on June 25, 1868. This photograph shows the 63 members of the reconstructed South Carolina Legislature. Fifty were black or mulattoes, and 13 were white. Twenty-two could read and write but some only minimally. Forty-one made their mark with the aid of a scribe. South Carolina had the first state legislature with a black majority when it rejoined the Union in 1868. Pictured here are, from left to right, (top row) Dusenberry, McKinlay, Dickson, Wilder, Hoyt, Randolph, and Harris; (second row) Mayes, Jillson, Lomax, Jackson, Thomas, Webb, Bozeman, Tomlinson, and Wright; (third row) Demars, Brodie, Cain, Maxwell, Martin, Cook, and Miller; (fourth row) Rivers, Duncan, Boozer, Smythe, Wright, Moses, Sanders, and Nuckles; (fifth row) Miteford, White, Barton, Shrewsbury, Mickery, Henderson, Howell, Hayne, Mobley, Hudson, Nash, and Carmand; (sixth row) Smith, Pentengrill, Hyde, Lee, Simonds, Chestnut, McDaniel, Williams, and Gardner; (bottom row) Swails, Perrin, James, Johnston, Wimbush, Hayes, Farr, Meade, Thompson, and Rainey.

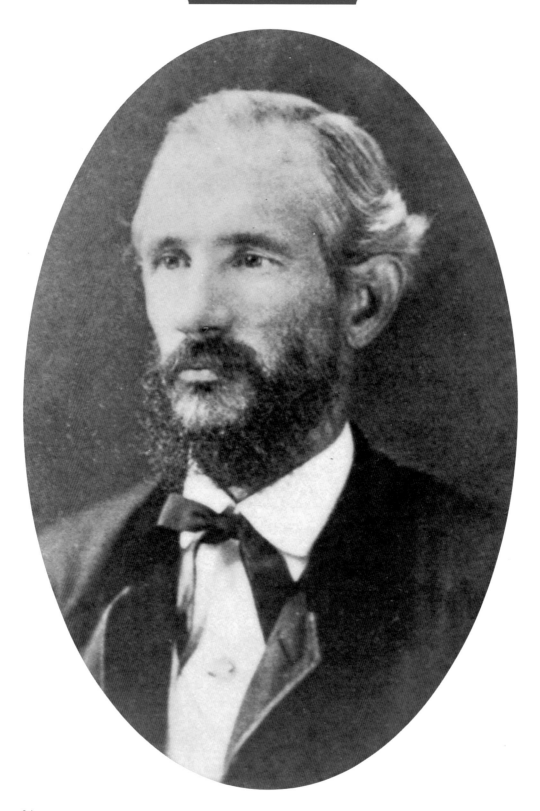

The Cathcart Family

John Wallace Cathcart came from Northern Ireland in 1899 and settled in Winnsboro. He started out with employment at the Winnsboro mill but soon worked his way into other occupations, such as real estate and banking. In the 1930s, Cathcart started one of the first banks in the county. The Cathcarts built their city home, a large Federal-style house, on Congress Street in downtown Winnsboro. The building, which was occupied by other owners, like educator Catharine Ladd, was donated to Fairfield County in 1969 by Ella Cathcart Wilburn and Carrie Cathcart Owings. It was entered into the National Register of Historic Places in 1970. In this picture, Ella and Kib Cathcart pose for a family picture in the 1920s.

Col. James Rion (OPPOSITE PAGE)

Rion was born in Quebec, Canada, but came to South Carolina early in his life. His mentor, John C. Calhoun, was instrumental in grooming him. He graduated first in his class at college in Columbia, South Carolina, then moved to Winnsboro in 1850 to teach mathematics, history, and military tactics at the newly formed Mount Zion Institute. Rion went on to complete his law degree, joined the military, and was appointed major of the Eastern Battalion of the 25th Regiment in the mid-1800s. His action in the formation of the Southern Party planted the early seeds of succession and political party unrest. During the Civil War, Rion served as commanding officer of the 7th South Carolina Infantry. However, Rion's military career was marked with major gallantries and unrest. His stubbornness often led to conflicts with his superiors. Colonel Rion was even arrested and almost court marshaled for "disobeying an order." Later, the judgment was reversed, and Rion went on to continue in the military as one of the best commanding officers in the Civil War. On the home front, Rion had one of the most grand and modern houses in town and lived there with his wife, Kitty, and his large family. He was very instrumental in the progress of Fairfield County, serving on many educational, business, and banking boards. Rion was active in the formation of the Rockton and Rion Railroad spur. He often got rights-of-way from local farmers so the railroad could transport granite from the quarries, which were also one of Rion's business interests. In downtown Winnsboro, Rion owned a joint tavern and hotel, which was the place to be at that time. Col. James Rion, a true Renaissance man, had many stories and exciting life adventures. He died at the age of 51. (Courtesy of James Gabel.)

William Hassel Gibbes III

The Obears of Fairfield County took in the Gibbes during the Civil War. When the coast was clear, William Hassel Gibbes returned to the Charleston area where his family retained their ancestral home. The William Gibbes House and the Gibbes Museum are regarded as some of the finest examples of 19th-century architecture and art in the South.

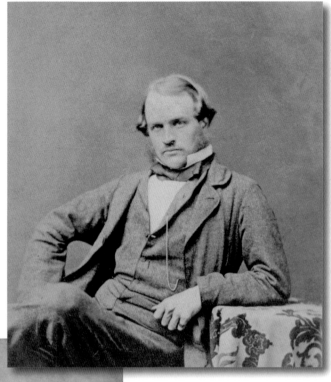

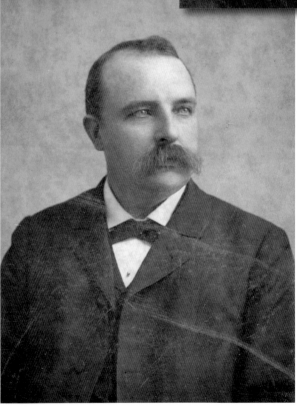

Glen Walker Ragsdale

Glen Ragsdale grew up during the post–Civil War era in Fairfield County. He worked on the family farm, attended Shiloh Academy, and then went on to Furman College. Glen followed his brother's footsteps and became an outstanding local attorney. He went into politics and served in the South Carolina Senate. It was there that he sponsored a law abolishing the antiquated system on legal court proceedings that prevented a technical eviction. (Courtesy of Elizabeth Steele Forman.)

Isabelle Wolfe Baruch (1850–1921)

Isabelle was the daughter of Sailing Wolfe, a wealthy Jewish planter in Fairfield County, and she married famous physician and leader Simon Baruch in 1867. Baruch had emigrated from Germany to South Carolina at the age of 15 to avoid persecution by the Prussian conscription. He worked at a general store and eventually went to medical school. Baruch had joined a South Carolina infantry in 1862 and became a chief surgeon on General Lee's staff during the Civil War. He was a pioneering physician, being one of the first doctors to use hydrotherapy treatment, and then establishing the first public bath in New York City. It was also said that Baruch was one of the first surgeons to accurately diagnose and perform appendectomies. The Baruchs had four children. Their second son, Bernard, made a fortune on Wall Street and was known as the "Park Bench Statesman." Isabelle raised her family in the Jewish faith and started a Sunday school working with the newly formed South Carolina Hebrew Benevolent Association, which Baruch helped finance. After the debacle of the famous Cash-Shannon duel, which Simon Baruch worked hard to prevent, the family relocated to New York City in 1881. This duel prompted South Carolina legislation to outlaw duels, an archaic act of honor and chivalry. In New York, Isabelle was on the Advisory Committee for National Defense and was the chairperson of the War Industries Board. She also sponsored many religious and artistic events in New York and South Carolina. The Baruch family extended their legacy through their gifts to the world in medicine, finance, art, music, and historical and environmental preservation. Baruch in Hebrew means "blessed."

Col. Austin F. Peay (1777–1841)
The Peays, originally French Huguenots, settled in the Longtown area of Fairfield County. This section was originally called "Log Town" because of the logging roads, but the name was soon changed to Longtown because, in the late 1700s, new wealthy plantation owners had arrived and built long roads through their properties. The son of Nicholas and Mary English Peay, Austin, a well-to-do plantation owner, attended the academy that was set up close by and was serviced by a scholarly educator. Colonel Austin was known as one of the richest men in the county with a net worth of more than $253,000. He was a particular man, and it was said that he started the idea of Pullman cars. When Peay rode in a train, he would travel at night. To be comfortable and not to lose sleep, Peay installed a mattress in his train. Col. Austin Peay served in the South Carolina House between 1812 and 1831 and in the South Carolina Senate between 1832 and 1839. He died a year later. Colonel Austin's mansion was built on Flint Hill; his son Nicholas built a grander mansion close by. Nicholas's mansion, named Melrose, had 30 rooms and luxury apartments. Slaves claimed there was a swimming pool on the roof that was also the fishing hole for fresh fish cooked for dinner. Because the majority of the Peays' property was on the Wateree River, Austin Peay was granted ferry rights in 1808. A ferry in this district ran as early as 1775. In 1820, the road from Wateree River to Liberty Hill was known as Peay's Ferry Road. The ferry was an important part of transportation during General Sherman's march across the South. But then, in 1919, the Wateree River flooded and covered the road at the old ferry site by the Wateree Power Company. Some of the Peay property, including the family graveyard, was buried in the river's waters.

CHAPTER TWO

Military Heroes

The British government originally recruited the inhabitants of Fairfield County to serve as a buffer. The new immigrants looked at this opportunity to fight for a new life of religious freedom and perhaps prosperity. These warriors learned to protect their family not only from Indians but also from bandits and other natural predators. Many strong, young men attended Mount Zion Institute in Winnsboro and then went on to the Citadel in Charleston.

David DuBose Gaillard, who became famous for his engineering feats at the Panama Canal, was one of these young, strong men. This famous ship canal, which was built between 1881 and 1914, connects the Atlantic and Pacific Oceans. The canal, one of the largest and most difficult engineering projects ever undertaken, was also plagued with disease and deadly sanitation issues. Probably due to canal exposures, Galliard died shortly before its opening. Another hero is Mount Zion graduate Gen. William O. Brice Jr., who became one of the youngest brigadier generals in the US Marines. Webster Anderson was ready to risk his life while fighting in Vietnam. When the enemy breached the battery defensive perimeter, Anderson directed howitzer fire upon the adversary. However, several hand grenades hit him, severely wounding his lower extremities. Still fighting, Anderson fired at the quickly approaching North Vietnamese. A second hand grenade came into the area, and Anderson seized it to protect a nearby soldier. Unfortunately, it exploded, taking his hand. Anderson survived and returned home to Fairfield County. As did William Belk, another famous Winnsborian, who came into national focus when he appeared in the media tied and blindfolded. He was one of the 52 hostages held by Iranians in Tehran for 444 days. The year was 1979, and political tensions were high. Unharmed, Belk eventually returned to a hometown celebration. Colonel Motes was a transplant to Fairfield County by way of his wife, who was raised in Winnsboro. Motes served in Vietnam as an advisor to the king and landed up advising the students in Fairfield County as a teacher and administrator. Carroll Pope, a proud ex-Marine, wanted to be in the service ever since he was a little boy. He was at the Citadel when he met then-president of the school, World War II hero Gen. Mark Clark, who was the youngest lieutenant general in the US Army at that time. Pope went on to become a Citadel graduate. Rose Young was a brave woman in the early 1900s. When most ladies were mothers or teachers, Rose signed up for the service. She kept a postcard diary, which she regularly mailed, to her relatives in Fairfield County. The collection details the travels of a young military woman who died too young at a military base in Mississippi. Other military heroes include Mike McCoy, Homer Childers, "Tabby" Hinnant, Kevin Douglas, and all of the other countless servicemen and servicewomen from Fairfield County. Thomas Woodward was known as the "Faifield County Protector," and he personified the philosophy of Fairfield County's servicemen and servicewomen—to defend and serve.

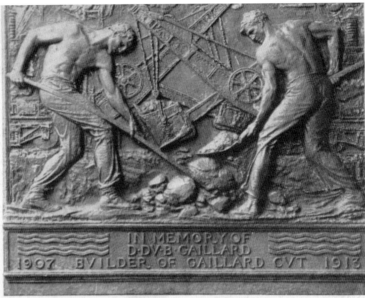

This memorial to Colonel Gaillard, for whom President Wilson renamed Culebra Cut in 1915, is located on Contractor's Hill 100 feet above the water. It is the work of James Earle Fraser, and was erected by the Third U. S. Volunteer Engineers and by the family.

GAILLARD MEMORIAL

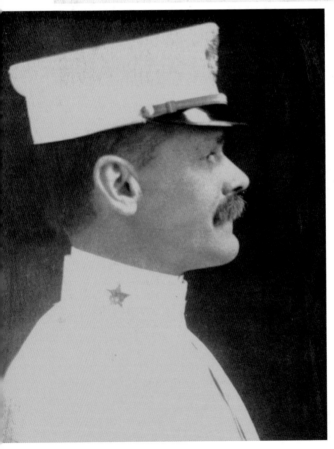

Lt. Col. David DuBose Gaillard
Gaillard, of the US Army Corps of Engineers, was assigned to the construction of the Panama Canal, which the United States took over in 1904. The young man was educated at Mount Zion Institute in Winnsboro and went to the United States Military Academy at West Point, graduating in 1884. One of his greatest feats was directing the engineering work in the Culebra Cut division of the Panama Canal. This waterway spread across the continental divide and rose 110 meters above sea level. It was barricaded by solid rock. Gaillard completed this most incredible engineering achievement, and thus, the canal was completed and opened in 1914. Because of the harsh conditions and injuries sustained during the project, Gaillard died on December 5, 1913, and regrettably never saw the opening of the canal. The Culebra Cut was renamed for him in 1915.

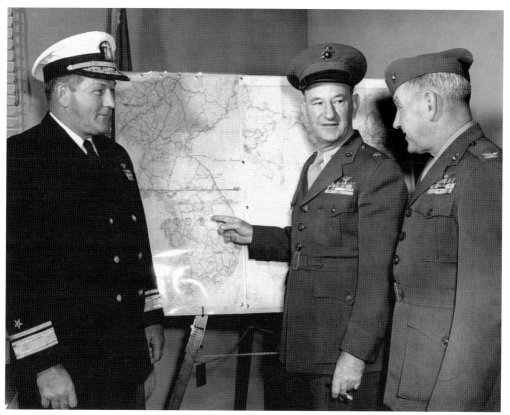

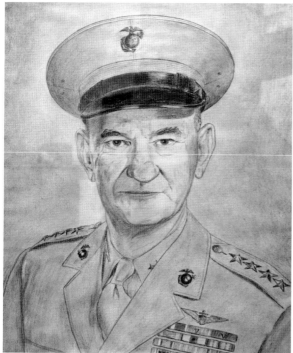

Gen. William Oscar Brice Jr. (1898–1972)

Brice, a graduate of the Mount Zion Institute and the Citadel, joined the US Marines, and was commissioned as a second lieutenant. As a naval aviator, he was assigned to protect Americans in China during the Chinese civil war. Because of his outstanding leadership and service, Brice was awarded many medals and merits and became one of the youngest brigadier generals, age 46, in the US Marine Corps at the time. He was also one of only four Citadel graduates to attain the four-star rank. Brice was inducted into the US Naval Aviation Hall of Honor in 2000. He died in 1972 and was buried in his family plot in Sion Presbyterian Cemetery in Winnsboro, South Carolina.

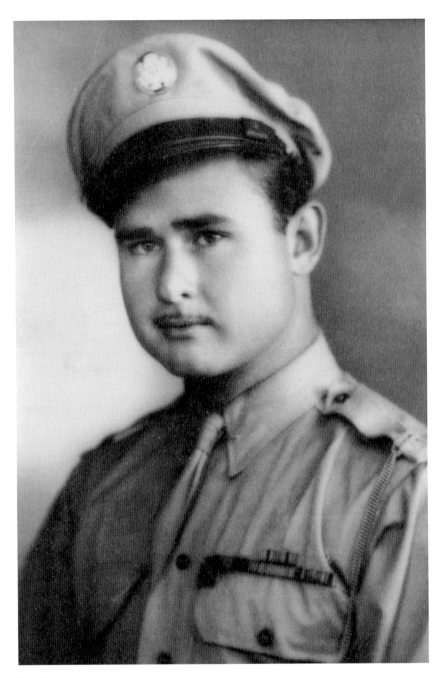

Mike Allen McCoy
Serviceman McCoy was assigned to the US Army 205th Military Police Company during World War II. He served in the European theater and received the Bronze Star, a good conduct medal, and the American Defense Service Ribbon. McCoy was also in the motorcycle entourage of Gen. Dwight D. Eisenhower, traveling to Italy, North Africa, Scotland, and Ireland. After the military, he graduated from barber school, owned a shop, and retired in 1973. Later, he retired again from Fort Jackson as the manager of its five barbershops. (Courtesy of Jan Albriton.)

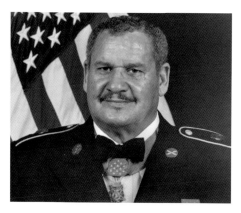

Sfc. Webster Anderson (1933–2003)

Anderson served in the Army and began one of his first tours during the Korean War. He went on to fight during the Vietnam War. In 1967, while a staff sergeant in Battery A, 2nd Battalion, 320th Field Artillery Regiment, 101st Airborne Infantry Division, his division was attacked by the North Vietnamese near Tam Ky. Anderson made an assault on the enemy, pulling himself into an exposed parapet to man a howitzer. Several grenades landed near him, and he was severely wounded, which led to the loss of both legs. In excruciating pain, he pulled himself back up into firing position and encouraged his fellow soldiers to continue to fight the oncoming North Vietnamese. Another hand grenade came toward Anderson and several nearby soldiers. Anderson tried to catch and release the grenade, but it went off in his hand. Though he lost both legs and one arm, Anderson survived to return home to Winnsboro and continued to give to the community. He retired at the rank of sergeant first class. For his actions of valor beyond the call of duty, he received the Congressional Medal of Honor, the highest honor in the US military. Anderson remarried after his first wife died in 1991. He died of colon cancer in 1996. Below, he is pictured with Pres. Richard Nixon.

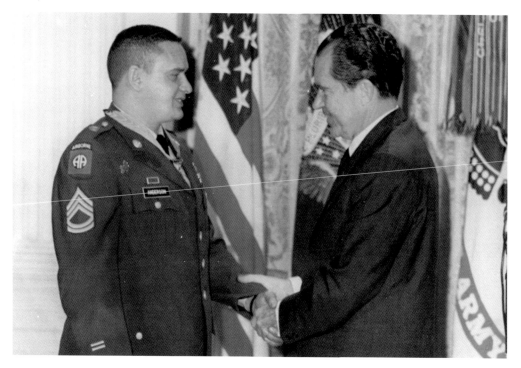

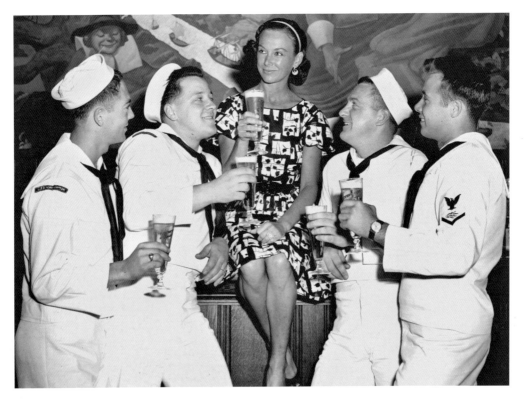

Homer Childers

Childers, from the Winnsboro Mill Village, started playing sandlot sports and went on to be voted Mount Zion School's most valuable football player for 1955. Later that year, he was chosen to play on the South Carolina all-star football team. In 1956, Childers won the Novice Heavyweight Golden Gloves Championship. He joined the Navy in 1956 and accumulated many awards including a Navy Commendation Award, campaign medal, Navy Achievement Medal, Armed Forces Expeditionary Medal, and Vietnam (RVN) Service Medal. Childers is currently a beekeeper living in York, South Carolina. Pictured are Childers (second from the left) and fellow sailors on leave in 1965, posing with an attractive beer representative in a New York brewery. (Courtesy of Homer Childers.)

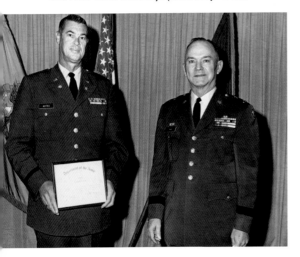

Col. Milford Motes

Milford Motes, an Army officer for 30 years, served as the advisor to the king of Vietnam while he was stationed in Laos. He also served as a commander of Fort McPherson, Third Army Command, in Atlanta, Georgia. Colonel Motes met his wife, Frances Smith, of Winnsboro, and decided to retire from the military and move to Fairfield County. Motes was employed as assistant principal and coach at Mount Zion High School, then as Winnsboro's city manager in the 1970s. Milford and Frances were active in leadership roles both in the military and the community. Pictured here, Motes (left) receives an award from Maj. Gen. Ray Laux (right).

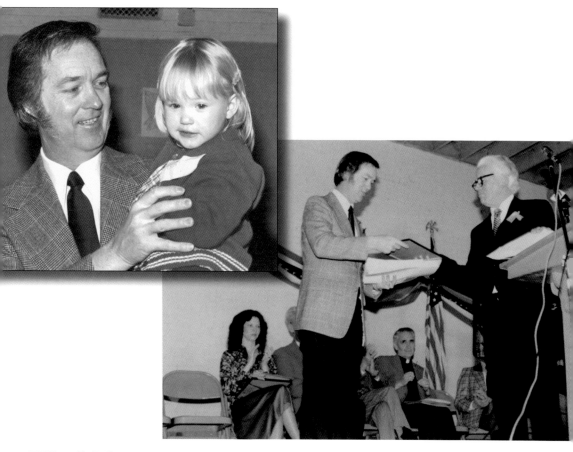

William E. Belk

Belk was serving as a US Embassy communication and records officer on February 1, 1979, when Ayatollah Khomeini returned to Iran and began to consolidate power. While Pres. Jimmy Carter allowed the Shah to visit America for cancer treatment in October 1979, Islamic radicals seized the US Embassy in Tehran. On November 4, a total of 53 people were taken hostage. The radicals, mostly Iranian students, feared the United States and Great Britain would help the Shah keep his power. The Iran Hostage Crisis was a pivotal episode in the history of Iran and the United States. After little hesitation, Jimmy Carter sent a rescue operation, though it had to be aborted when helicopters malfunctioned. Walter Cronkite, anchorman for *CBS Evening News*, measured the length of the event by adding a count of the days to his famous sign-off. The hostage situation, along with the deepening economic crisis, may have cost Carter his reelection bid. After the 1980 election, Carter tried harder than ever to get the hostages released, but the Iranians made it a point to release them just minutes after Ronald Reagan was inaugurated. William Belk was in the limelight as the first hostage pictures were released. The kidnappers flagrantly portrayed abuse and political desecration in their communication with the media. The Iran Hostage Crisis was life-changing for those involved and for the American population. Belk, originally from Winnsboro, but now retired and living in Georgia, said this: "The United States has bred contempt in the Muslim world by flaunting its power, wealth, and lifestyle. We have misjudged so many things in so many different countries. One of the failures of being an American is that we do not know enough about other people. We may not have these problems if we did not back these doctoral regimes." Pictured above left is William Belk in Winnsboro with his niece Erica Belk shortly after he was released in 1981. Above right, Belk receives an honorary award at a welcome home event in Winnsboro shortly after his return to Fairfield County. (Above left, courtesy of Erica Belk).

Robert Earl Hinnant (1918–2006)
Maj. Robert Hinnant, nicknamed "Tabby," was born in Fairfield County, as was his grandfather Capt. William George Hinnant, the famous Confederate soldier who was wounded and survived to be one of the forefathers of Ridgeway. To show off his hometown, Major Hinnant named his aircraft *City of Ridgeway*. He served in the Air Force during World War II, where he was a hero, winning many award citations with the 342nd Bomb Squadron, 97th Bomb Wing.

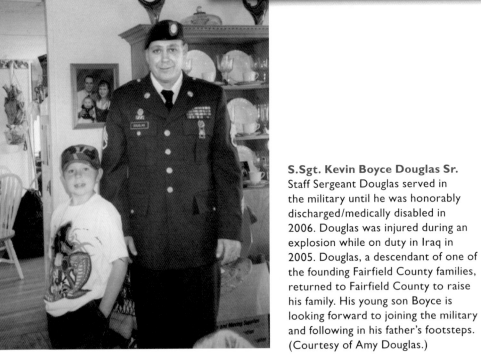

S.Sgt. Kevin Boyce Douglas Sr.
Staff Sergeant Douglas served in the military until he was honorably discharged/medically disabled in 2006. Douglas was injured during an explosion while on duty in Iraq in 2005. Douglas, a descendant of one of the founding Fairfield County families, returned to Fairfield County to raise his family. His young son Boyce is looking forward to joining the military and following in his father's footsteps. (Courtesy of Amy Douglas.)

Rose A. Young (1882–1917)
Young grew up in the Longtown section of Fairfield County and joined the US Army Nurse Corps in 1913. She attended City Hospital School of Nursing in New York City and graduated in 1907. Young had the opportunity to serve in hospitals all over the world, during peace and at war. Her decorations and awards included the World War I Victory Medal and the World War I Honorable Lapel Button. Young died at Camp Shelby Hospital in Hattiesburg, Mississippi. She was buried at the Ebenezer Associate Reformed Presbyterian Church in Winnsboro. (Courtesy of Sarah Sexton.)

Postcard Collection
As a Red Cross nurse, Rose Young traveled to many places and served in many hospitals worldwide. She collected and sent many postcards to her relatives in Fairfield County. Her family's collection of postcards includes some rare scenes from the early 1900s. (Courtesy of Sarah Sexton.)

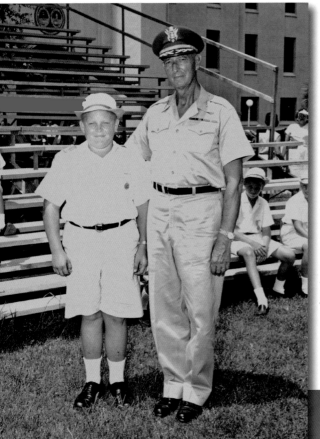

Carroll Lewis Pope Jr.

Carroll Pope Jr., a Citadel graduate and local owner of Red Hand Farm, is pictured with World War II hero Gen. Mark Clark. General Clark was the commander for the US military in Italy during World War II. In 1944, the general made his famous triumphant entry into Rome. Clark was the youngest to ever be promoted to the rank of general, in 1945. After retiring from the military, he became president of the Citadel, serving from 1954 to 1965. At left, General Clark presented the Mark Clark award to young Carroll Pope. Pope is a proud Citadel graduate and former Marine. He eventually became a minister but now is retired. Pope now farms and does occasional sermons at local churches. He poses below in his Marine dress uniform. (Both, courtesy of Carroll Lewis Pope Jr.)

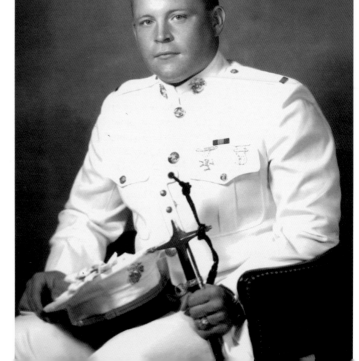

CHAPTER THREE

Educators and Missionaries

People from Fairfield County are religious. Many immigrants moved here for the opportunity to freely worship. Two Seventh-day Adventist groups started a congregation as early as 1740–1750. In 1762, Jacob Gibson, a Baptist minister, is thought to have started the first school while John Nicholas Martin, brought many Lutherans from Germany. An Episcopalian priest started a meetinghouse, and E.G. Palmer brought together the Episcopalians at Saint Stephen's Church in Ridgeway. The Universalists were located in the "Dark Corner" of Fairfield County, and the Reformed Synod of the Carolinas was organized at "the old brick church," also known as the Ebenezer Associate Reformed Presbyterian Church. The Latter-day Saints of Jesus Christ came to Fairfield County shortly after its conception, and Mormon wards are present in many local Indian reservations. Fairfield County has been served by a Presbyterian congregation since 1785. Richard Furman, an influential Baptist leader, spawned the famous Furman Institute, which had a brief presence in the county in the 1800s. James Carlisle, an influential leader of the 19th century and the "Grand Old Man of Methodism," was born and raised in Winnsboro. Many Jewish people settled in South Carolina to avoid Prussian persecution. South Carolina was the birthplace of Reform Judaism in the Americas and was the first place in the Western world to elect a Jewish person to a public office. Ministries also became part of the religious South. These organizations helped the poor with necessities and guided others through religious programs. Reverend Ike, from Ridgeway, built a religious empire and, through media, brought his spiritual fervor to many. For the most part, Fairfield County was a place for religious freedom and worship. Religion and education were powers no one could take away from these strong people who always had their share of obstacles. This rural community also relied on its churches for social and educational activities.

Education was a large focus in Fairfield County, as well. Winnsboro housed one of the most prestigious male preparatory schools in the South. Mount Zion Institute, established in the 1700s, was the forerunner for public schools in the state. Kelly Miller Elementary School was named after a child born to a free Negro and a slave, who went on to become a great educator and philosopher. Religious leaders Carlisle and Furman, who based their spirituality on philosophy and science, brought schools together in their community. John Feaster, also a religious leader, employed Catharine Stratton Ladd to teach at Feasterville. Ladd eventually opened one of the finest girls' schools in the South. Grover Patton came to Winnsboro to become the superintendent of Mount Zion School. He loved education and politics, and the people of Fairfield County loved him. Another well-respected Mount Zion employee was famous band teacher Walter Graham, who was a man ahead of his time, some would say. Louise Price was voted one of the most memorable teachers in the 1950s and 1960s. She was a working mother and a firm but caring teacher. Her husband, known as Coach Monk, was honored after his early death through the Coach Monk Award that is given to exceptional school athletes. Rev. Eddie Woods, originally from Ridgeway, mentors troubled youth through his books and lectures. Fairfield County's people are true missionaries, people who want to help fill the needs of the community.

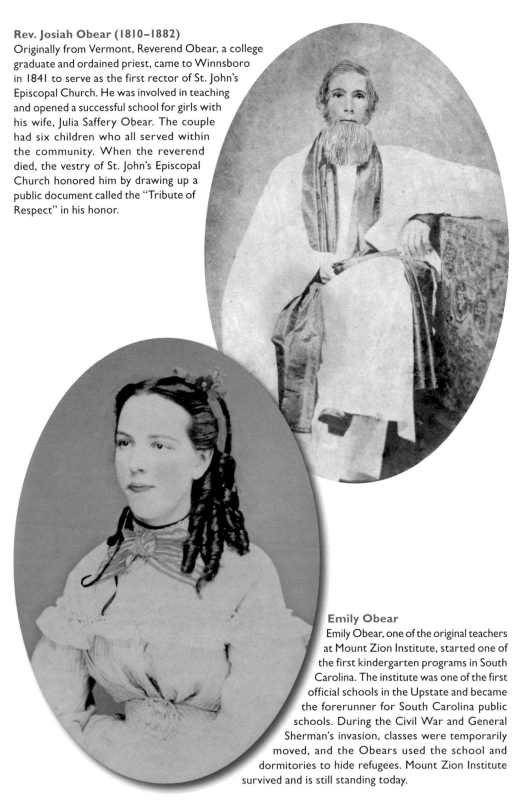

Rev. Josiah Obear (1810–1882)

Originally from Vermont, Reverend Obear, a college graduate and ordained priest, came to Winnsboro in 1841 to serve as the first rector of St. John's Episcopal Church. He was involved in teaching and opened a successful school for girls with his wife, Julia Saffery Obear. The couple had six children who all served within the community. When the reverend died, the vestry of St. John's Episcopal Church honored him by drawing up a public document called the "Tribute of Respect" in his honor.

Emily Obear

Emily Obear, one of the original teachers at Mount Zion Institute, started one of the first kindergarten programs in South Carolina. The institute was one of the first official schools in the Upstate and became the forerunner for South Carolina public schools. During the Civil War and General Sherman's invasion, classes were temporarily moved, and the Obears used the school and dormitories to hide refugees. Mount Zion Institute survived and is still standing today.

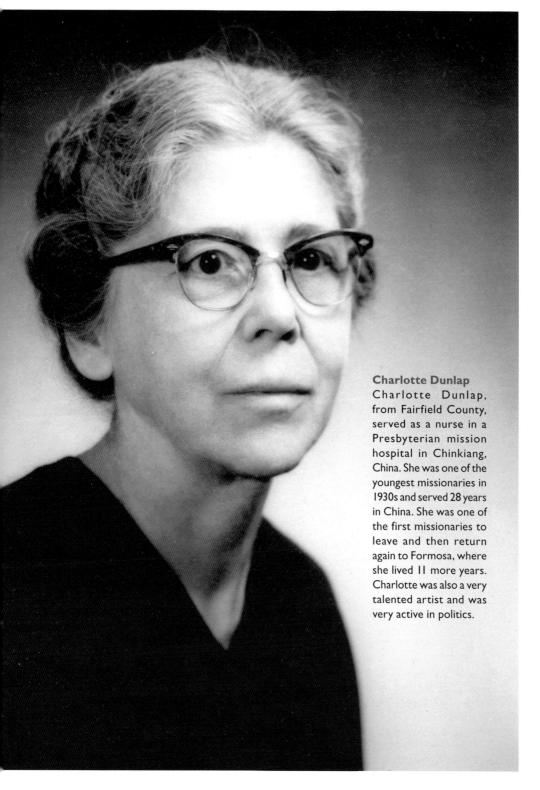

Charlotte Dunlap
Charlotte Dunlap, from Fairfield County, served as a nurse in a Presbyterian mission hospital in Chinkiang, China. She was one of the youngest missionaries in 1930s and served 28 years in China. She was one of the first missionaries to leave and then return again to Formosa, where she lived 11 more years. Charlotte was also a very talented artist and was very active in politics.

David Branham and the Mormon Church

David Branham was one of the original bishops in the Fairfield County Ward of the Church of Jesus Christ of Latter-day Saints (Mormons). In the mid 1800s, Branham preached from the historically noted Anvil Rock. Pictured above, Anvil Rock—a granite pedestal about 10 feet high with a length of 12 feet—still sits on part of the land granted to Thomas Woodward, a Fairfield County Regulator. Below are descendants of the original bishop, posed in front of the Ridgeway Ward around 1970. They are, from left to right, (first row) Elaine Dove, Mary Francis Enloe, Jewel Kelly, Patricia Dove, Willette Reynolds, Annette Branham, and Patricia Branham; (second row) Odel Branham, Gladys Branham, Gertrude Kelly, Eliza Wilson, Diane McLamb, Sue Pixley, and Kenneth Branham. The Latter-day Saints church had one of the largest religious congregations in Fairfield County just a few years after the religion's origination in 1830. Between 1897 and 1986, the Latter-day Saints had a total of five buildings. Even though the Mormons had a large presence in the county, they also met much resistance. The Mormon church still stands in Fairfield County, and it celebrated its 100th year in 1994.

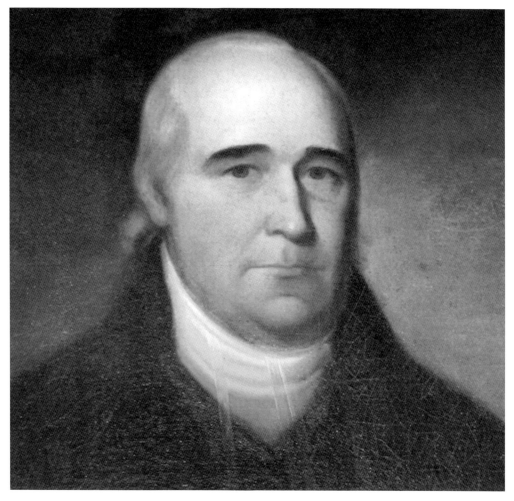

Richard Furman (1755–1825)
Furman was an influential Baptist leader from South Carolina. He was the first president of the Triennial Convention, the first nationwide Baptist association, and later became the first president of the South Carolina State Baptist Convention. During the Revolutionary War, Furman volunteered to serve, but his talents as a speaker led him to be a recruiter for the cause rather than a soldier on the field. When he was in Charleston and the British forces gained control in 1780, Gen. Lord Charles Cornwallis, who had heard of Furman's great influence, offered a bounty for his capture. Furman fled the state for a short period of time during the Revolutionary War. A men's theological college named in Furman's honor was founded in 1826 in Edgefield, South Carolina, and was then moved to Greenville. Later, in the 1800s, the school became philosophically and financially unstable. One of the trustees of the university, Rev. Jonathan Davis, of Fairfield County, persuaded to move the school to the large acreage he had purchased not far from his home and family church. The original frame construction that housed the dormitory, library, and classrooms were built in 1847. The school of theology flourished there, however, soon after the buildings were constructed, some of the buildings burned. The loss of property along with other conflicts convinced the trustees to move the university back to Greenville in 1851. Today, Furman University, empowered by Richard Furman's philosophy and religious values, offers majors and programs in more than 42 subjects. The remnants of the Fairfield County Furman Institute can still be seen in its original location in Fairfield County. (Courtesy of Furman University.)

Walter Graham

Fairfield County music director Walter Graham loved music, and the students loved him. "Mr. Graham and Mrs. Sprott trained fifth- through seventh-graders at Mount Zion School and Everett Elementary School to read music and sing harmony like the Vienna Boys Choir. Under Mr. Graham's direction, our school's choir won the Southeastern Children's Competition in Asheville, North Carolina, and got to record an album," said Pelham Lyles. In this photograph, Graham is conducting the flute band at Mount Zion Institute around 1955. Unfortunately, the county decided that it needed someone who specialized in marching bands and not concerto music. Even though many citizens disagreed, Graham was replaced.

Rev. William Rose (OPPOSITE PAGE)

The Rose family moved to Winnsboro in 1966 when the reverend was assigned to St. John's Episcopal Church. Reverend Rose and his wife, Beatrice, touched many people in the county through counseling and bringing folks into the church fold. In 1979, Reverend Rose was transferred, this time to the Church of the Good Shepherd in downtown Columbia. The Roses always kept ties to their old congregation in Fairfield County. Many people still consider the couple their "adopted parents" even though they have retired and moved to Beaufort, South Carolina. Reverend Rose lives for his Godly mission and maintains two small churches. The reverend is seen on the opposite page in the above photograph on the bleachers of Winnsboro High School with others during a visit by Sen. Strom Thurmond. Shown are, from left to right, (first row) Edward McMaster, Nancy Thurmond (wife of Strom Thurmond), and Claude Ragsdale; (second row) Rev. William Rose, Martha Woods, and Dick Woods. Pictured in the bottom photograph, from left to right, Reverend Rose, unidentified, and Martha and Fred Craft get together for a fundraiser for the Fairfield County Mental Health Association.

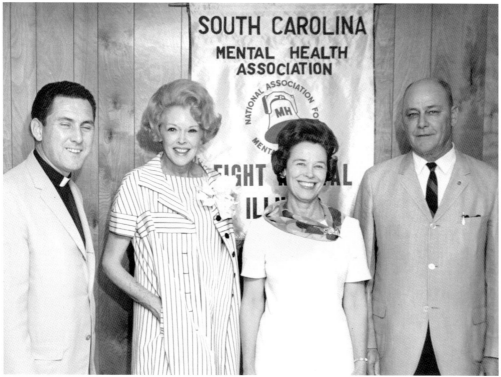

Frederick J. Eikerenkoetter II (1939–2009)

Eikerenkoetter, affectionately known as "Reverend Ike," was born in Ridgeway. He was of Indonesian-Dutch and African American descent. Reverend Ike became a self-taught evangelist in the Bible Church of Ridgeway when he was a teenager. His charisma and spiritual fervor vaulted him into the position of assistant pastor. Eikerenkoetter then joined the Air Force, serving as a chaplain service specialist, which he used as a vehicle to expand his ministry. The reverend started a church in Beaufort called the United Church for Jesus Christ. He then moved to Boston and created the United Christian Evangelistic Organization and finally to New York City, where he opened the Christ Community United Church. Eikenrenkoetter created the Christ United Church, also known as the "Palace Church," in the Washington Heights district of Manhattan. This building was formerly the Loew's 175th Avenue movie theater and was painstakingly remodeled to include a place for the Robert Morgan seven-story organ and the "Miracle Star of Faith" atop the cupola, which can be seen from the George Washington Bridge. Reverend Ike housed his spiritual and educational mecca in this building. Upon his death in 2009, his only son took over as minister and chief officer of the empire. He follows in his father's footsteps and continues to preach at the nondenominational, nontraditional Palace Church. Reverend Ike's ministry also lives on through radio and internet media, DVDs, and other materials within the Reverend Ike organization. The reverend was very popular in the 1970s when his radio sermons reached hundreds of stations across the United States. His controversial "Blessing Plan" provided prayers to his audience in return for monetary donations. His show and slogans inspired many artists, such as John Lennon, who wrote "Whatever Gets You Through the Night," and a country-western song named "Mind Your Own Business." His most famous slogan was "You can't lose with the stuff I use."

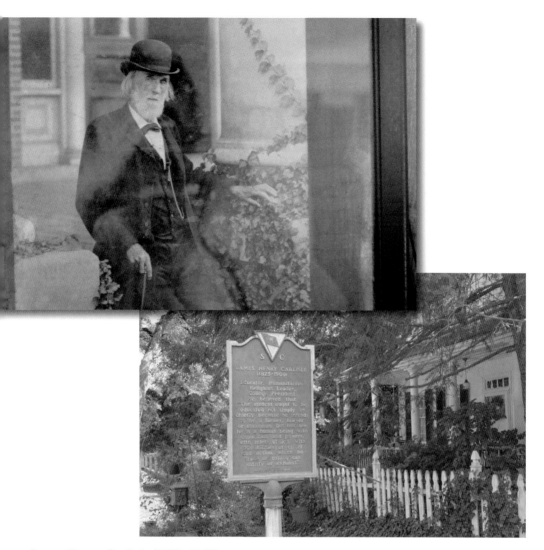

James Henry Carlisle (1825–1909)

Carlisle's family emigrated from Northern Ireland and settled in Fairfield County, where he was educated at South Carolina College. At age 29, he accepted a position at Wofford Methodist College in Spartanburg. Though he was officially the professor of mathematics, he preferred teaching religion and morals. Carlisle was known as the "Grand Old Man of Methodism" and was an influential leader in the 19th century. He settled at Wofford for 50 years and served as the president of the college from 1875 to 1902. He believed the following: "The student ought to be educated not simply or chiefly because he intends to be a farmer, lawyer, or statesman, but because he is a human being with capacities, and powers, with inlets of joy, with possibilities of effort and action, which no trade or calling can satisfy or exhaust." Carlisle was elected into the House of Representatives during the Civil War and eagerly signed the Ordinance of Succession, often fearing repercussions. The Carlisle family gravesite is located at the First Methodist Church in Winnsboro. Above is a photograph of the house where Henry Carlisle was born on May 25, 1872. It still stands just a few feet from the famous clock tower marketplace. Carlisle was the son of William and Ann Carlisle and was known as an outstanding educator, humanitarian, and religious leader. The Fairfield County Historical Society erected the historical marker for the Carlisle house in 1965.

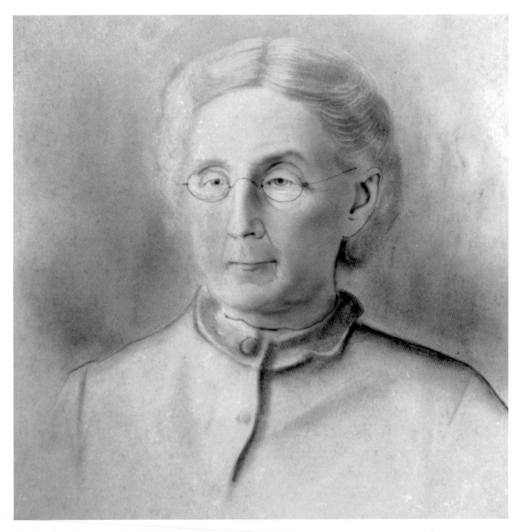

Catharine Stratton Ladd (1809–1899)
Catharine Ladd, one of the most noted teachers in the state of South Carolina, established one of the largest institutions of learning for women in the state. The year was 1848, and the Winnsboro Female Institute would become a counterpart to Mount Zion Institute in Fairfield County. Originally from Virginia, Catharine had married at age 18 to well-known portrait and miniature painter George Ladd, and they moved to Fairfield County in the early 1840s. Catharine started teaching at the newly formed Feasterville Academy, then bought the Cathcart house to teach and manage her own school. Catharine also enjoyed poetry and art and had many of her works published throughout the South. She adored beauty and gaiety but dressed plainly and unadorned, and she wanted her girls to know grace, manners, and etiquette. The institute closed right before South Carolina's secession from the Union in 1861. Catharine then organized the women of Winnsboro to develop the Soldiers' Aid Association. She is thought to have contributed to the designing of the Confederate flag. During the burning of the city, Catharine helped save the Masonic jewels from destruction but unfortunately lost everything. After the war, the boarding school was financially insecure, as were the citizens, so she spent her time bringing arts to the community. In 1870, she went back to teaching but had to quit because of an eye disease and diminished sight. She died in 1899. This photograph is a middle-aged picture of Catharine drawn by an unknown artist.

Kelly Miller (1863–1939)

Miller, one of the most progressive black educators during the early 20th century, was born into a large family in Winnsboro. His father was a free black person who served in the Confederate army during the Civil War, and his mother, Elizabeth Roberts, was a slave. Miller was educated in one of the schools created after Reconstruction. The Rev. Willard Richardson, a local missionary, noticed this young man's academic aptitude, and helped Miller get into the Fairfield Institute, an African American school in Fairfield County. Miller completed his curriculum of Greek, Latin, and mathematics in a quick three years and went on to attend Howard University in 1882. He also worked for the US Pension Service during his schooling and then again after he graduated. Miller was the first African American student at Johns Hopkins University. After graduation, he took on various leadership roles at Howard University. Miller went on to publish and lecture on many topics and was often known as the "philosopher of the race question." A school and several landmarks have been named in his honor in Fairfield County. (Author's collection.)

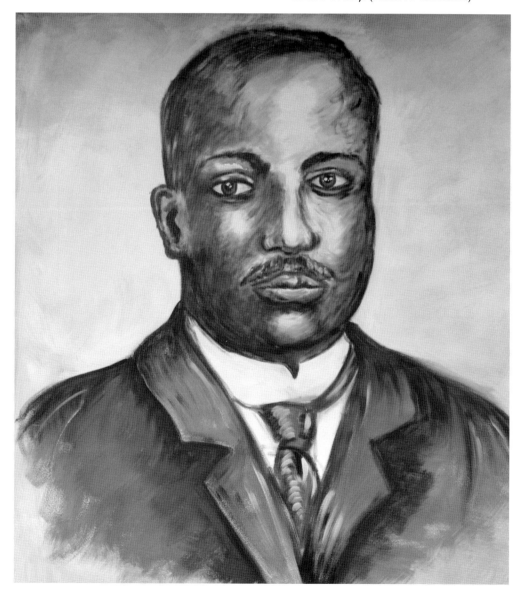

Grover Folsom Patton

Patton, of Scotch-Irish descent, was an Upstate South Carolina man who graduated from Wofford College and Georgetown University School of Law. He served as superintendent of schools in Hartsville, South Carolina, then came to Winnsboro to teach and work as superintendent of Mount Zion Institute. He ran for state representative in 1942 but lost, despite the fact that many thought he would be a great politician because of his upright character and outstanding intellect. Patton, disappointed in his endeavor, claimed that, "Rarely are statesmen elected to public office." Patton was not only a well-respected citizen of Fairfield County, he was also a beloved teacher. He served at Mount Zion Institute for 24 years. When he retired, he was honored with a large silver Paul Revere bowl inscribed with the following: "Presented to Mr. and Mrs. Grove Patton by the student body of Mount Zion Institute in appreciation of their years of loyal service (1919–1943)." Patton was honored in life and after passing. On his tombstone, the following words appear: "Eminent scholar, beloved teacher, inspiring educator, admired leader, friend to many. His influences for good will endure throughout the years." Patton was born on October 14, 1884, and died in Winnsboro on May 20, 1970, at age 85. He was married to Natalie Dwight, daughter of Capt. Charles Steven Dwight and Maria Louisa Galliard. Captain Dwight, of the US Army Corps of Engineers, wrote an account of his years fighting in the Civil War. The document, "A South Carolina's Rebel's Recollections," can be found at the Fairfield County Historical Museum. Here, Patton is at home in his office in the 1950s.

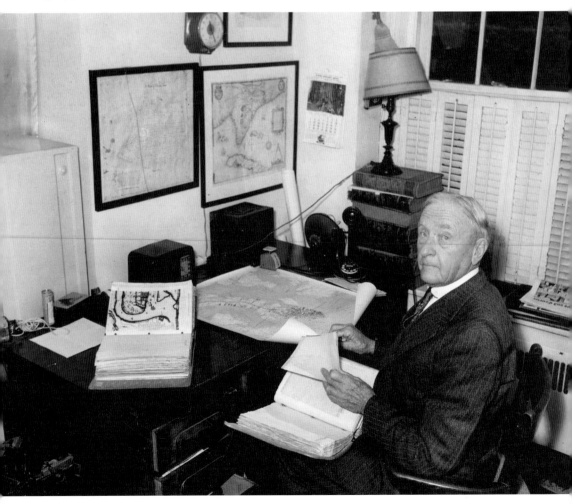

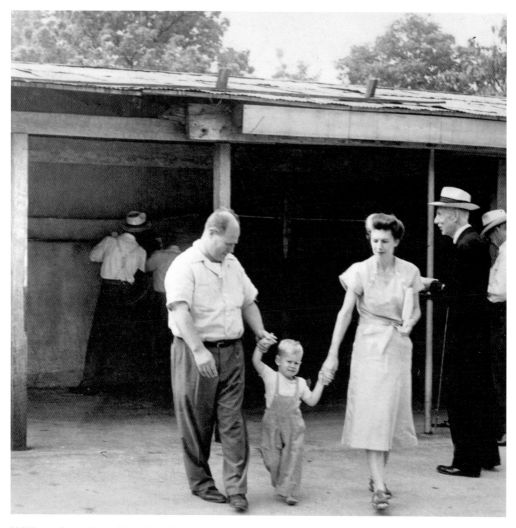

William Russell and Louise McCollough Price

The Prices were well-known educators in Winnsboro. Coach "Monk" Price and Louise McCollough were married when they were both in their late 30s, a rarity for folks back in the 1940s. Monk was a coach at Mount Zion Institute until 1955, when he passed away and left Louise with two small children. Coach was a firm but loving mentor, and in his memory, a William R. Price Memorial Trophy was given to outstanding athletes for a number of years at the school. Louise taught sixth grade and was voted as one of the most memorable teachers, though some may have feared her; she was strict but caring. One student remembered Louise's gift to the students for Christmas: tissues. She wanted to instill personal hygiene into her students and was appalled that some homework papers were not very sanitary. Another student remembered her as a disciplinarian. After a student infraction in the class, the group was asked to form a committee to discuss the punishment. A committee in the sixth grade was quite a unique request. Louise died shortly after this confrontation, only six weeks into the school year. People remembered that she was a heavy smoker and that her family had a tobacco farm. Everyone smoked, an unfortunate consequence of the times, living in rural farm country. Many folks regarded Louise as a strong and determined lady, especially as a single mother in the early 1950s and 1960s. In this photograph, Louise and Monk leave a voting booth with their son Rusty in the 1940s.

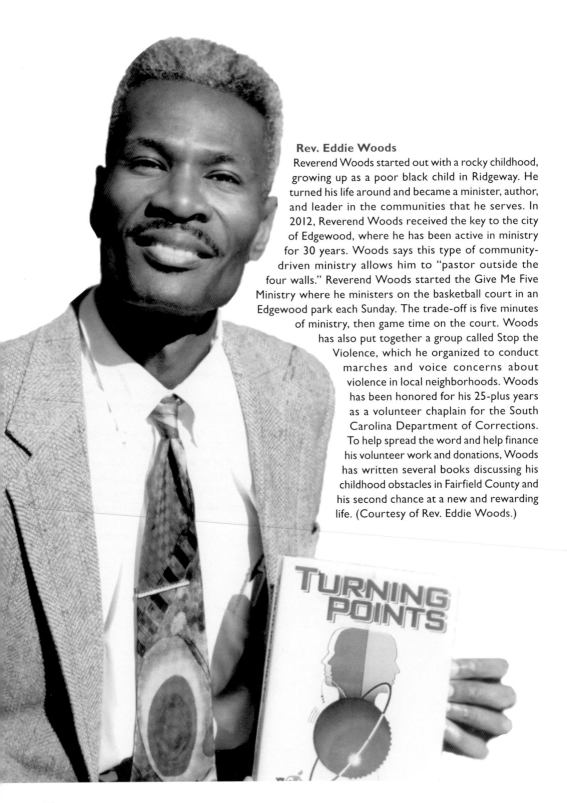

Rev. Eddie Woods

Reverend Woods started out with a rocky childhood, growing up as a poor black child in Ridgeway. He turned his life around and became a minister, author, and leader in the communities that he serves. In 2012, Reverend Woods received the key to the city of Edgewood, where he has been active in ministry for 30 years. Woods says this type of community-driven ministry allows him to "pastor outside the four walls." Reverend Woods started the Give Me Five Ministry where he ministers on the basketball court in an Edgewood park each Sunday. The trade-off is five minutes of ministry, then game time on the court. Woods has also put together a group called Stop the Violence, which he organized to conduct marches and voice concerns about violence in local neighborhoods. Woods has been honored for his 25-plus years as a volunteer chaplain for the South Carolina Department of Corrections. To help spread the word and help finance his volunteer work and donations, Woods has written several books discussing his childhood obstacles in Fairfield County and his second chance at a new and rewarding life. (Courtesy of Rev. Eddie Woods.)

CHAPTER FOUR

Faces of Progress and Industry

The rolling hills and fertile soil provided a perfect place for farmers, from big plantation owners to small family sharecroppers. Fairfield County is surrounded by lakes, rivers, and ponds. The abundance of hunting and fishing also drew settlers from northern states. Wild turkey, deer, and boar were plentiful. Lake Monticello and Lake Wateree were popular places to fish, camp, and enjoy recreational activities. Hunting, hunt clubs, and fishing are still popular today in Fairfield County.

Of course, as in most southern states, cotton was the number one crop in the 1800s. However, because of soil erosion and the infestation of the boll weevil, harvests were severely depleted by the 1920s. Fairfield County relied on its many granite quarries to provide economic stability. Today, one can still see many houses and buildings constructed of blue granite. The South Carolina Courthouse, the Land Title and Trust Building in Philadelphia, and the Flat Iron Building in New York were all built from Fairfield County granite.

The railroad was also important. The original Rockton and Rion Railway was constructed between 1883 and 1900 and ran from Rockton to the granite quarry at Rion, then onto the quarry at Anderson, 12.5 miles west of Rockton. From its inception until its cease in operations in the mid-1970s, the Rockton and Rion's primary purpose was to haul granite from the two quarries operated by the Winnsboro Granite Company to Rockton, where the loaded train cars were delivered to the Southern Railroad. During the late 1960s, the Rockton and Rion was one of the last railroads in the country still operating steam engines on a regular basis.

The railroads brought industry, and many families took advantage of the transportation access and the oil and gas reserves. A nuclear plant was set up in Fairfield County near Monticello, in the western portion of the area. Progress started in Winnsboro, the center of the county where stores and shops opened on Congress Street, the main thoroughfare. For many years, the street was segregated with blacks shopping on one side and whites on the other, though the stores were open to everyone. Winnsboro had grocery stores, general merchandise stores, oil and gas stations, feed stores, and, later, department stores. Unfortunately, as the economy and retail marketing changed, many of the mom-and-pop shops went out of business.

But out in the country, people still farmed, raised cows, horses, turkeys, and goats, and even made homemade barbecue. Others took leftovers such as cooking oil and made fuel. The resourceful people of Fairfield County continue to progress in the ways they know best.

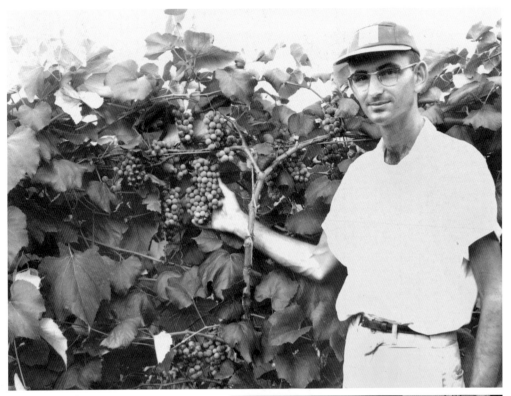

Sabie Cathcart (1903–1967)

The Cathcarts, from Northern Ireland, were some of the original settlers, farmers, and landowners in Fairfield County. They brought goats, mules, and other animals into the county in the early 1800s. In 1934, grapes were a popular crop in the county. Here, Sabie Cathcart shows off his award-winning vineyards.

A.E. Davis

A.E. Davis, originally from the Monticello region of the county, operated a popular farm and feed store on Congress Street in downtown Winnsboro. Kids loved going into the A.E. Davis Feed and Seed Store to buy pink- and blue-dyed chicks around Easter time. Many people still remember the smell of hay, feed, chickens, and boiled peanuts. A fitness center is now located where the feed store stood in the 1940s and 1950s.

Davis Robinson

Davis and Marion Robinson, farm boys growing up in the rolling hills of Fairfield County, know their pigs. Some say that they have the best ribs and butts in the county. They owned the famed Mister Hawg's Barbecue, which grew from the traditional backyard cookout. "The secret was to cook and sell on the last Saturday of the month," Robinson explained, "The last Saturday of the month is always going to be the light of the moon and our hash pots will overflow if we aren't careful." Unfortunately, the nationally known hash masters have now hung up the pot and retired to fixing barbecue for family and friends on occasion. Pictured are Davis Robinson and his classmate Judy Lyles Glover, from Greenbriar High School's class of 1957, as they show off the 4-H monument that stands on Highway 321 at the Richland-Fairfield county line. The 4-H Club is an organization that helps youth study different fields as a way of positive youth development; the four Hs stand for head, heart, hands, and health.

Benjamin Hornsby Jr.

Benjamin and Annette Hornsby are the children of Sen. Benjamin Hornsby Sr. of Fairfield County. Benjamin Jr. served on the board of the South Carolina Federation of Local Historical Societies and is currently an active member of the Fairfield County Historical Society. At right, Benjamin Jr. poses with his sister Annette on the W.P. Ruff farm. They both received awards for grand champion animals at the Fairfield County Livestock Show in 1957 and 1959, respectively. These promotions were part of the Community Development Program associated with Clemson Extension Service. Below, Benjamin Jr. (left) and Ed Gates, board members of the Fairfield County Historical Society, enjoy entertainment during the New Harmonies Music Festival, an event sponsored by Congress, the South Carolina Humanities Council, the Fairfield County Historical Museum, and the town of Winnsboro. (Right, courtesy of Benjamin Hornsby Jr.; below, Author's collection.)

Verola Barber Maples
Verola Maples, from Ridgeway, is one of the last original midwives in Fairfield County. She graduated from nursing school in the 1960s and went anywhere she was needed to deliver local children. "I would birth babies everywhere and anywhere, from the hospital to the patient's home," said Maples. A big believer in midwifery, she had 14 children; all except the last one were born at home with the help of a midwife. Even at age 86, she recalls many of her "birthed babies." Pictured is Maples delivering the baby of Dick and Norma Carillo around 1960. The photograph journal of this birth was on display at several exhibits throughout the state showcasing South Carolina midwives.

Luke Dargan (OPPOSITE PAGE)

Luke Dargan (left) was chairman of the Forest Advisory Committee of the American Farm Bureau Federation, commissioner of the South Carolina Water Resources Commission, board member of the South Carolina Forestry Association, and a member of the South Carolina Governor's Advisory Council on Natural Resources. Luke, active in Boy Scouts in the Winnsboro area, received the Beaver Award and assisted his wife, a Girl Scouts troop leader, with Girl Scouts activities. Quay McMaster, mayor of Winnsboro, is pictured on the right.

William Henry Belk

William Henry Belk, merchant and founder of the Belk department store chain that bears his name, was born in South Carolina in 1862. His father, Abel, was drowned by a Union general in 1865 who was ordered by General Sherman. Eventually, the family moved to North Carolina. The Belk family-owned chain store opened in Winnsboro in 1929 and was managed by J.W. Stephenson Jr., then by his son J.W. Stephenson II. It was a favorite place to shop in Winnsboro for several decades. Folks remembered the X-ray shoe-measuring gadget, the damp and dark bargain basement, and the festive Christmas decorations that included a huge animated Santa. A portrait of W.H. Belk greeted the townspeople until the late 1960s.

Garris McCabe Ladd Jr.

Ladd, a descendant of Catharine Stratton Ladd and George Ladd, grew up in Dawkins, Fairfield County, and attended Monticello High School. He was ranked as one of the top students in the state and was only 16 when he attended the University of South Carolina, making him the youngest student to attend the university at the time. His family had a store in the countryside, selling food and clothing, but they moved to Winnsboro by the time Garris had married Dorothy "Rochie" Cooper at age 22. Garris completed two years of college, then worked several jobs in town before doing what he knew best—the grocery business. He started a store in town and, after several location changes, settled into a property owned by his parents that was located in downtown Winnsboro on Congress Street. It was there he and his wife worked side by side. Rochie died young at the age of 51, but Garris continued to work until his retirement in the mid-1980s. Ladd Grocery Store had a great reputation for the freshest meats and vegetables in town. Garris would go to the state farmers' market every day, often starting out before 4:00 a.m. to get the best hand-picked produce. Some was grown locally by his father, Garris Sr. His tomatoes and watermelons were always in great demand. Garris's number one rule was to treat his customers with respect and friendliness. He would help out those in need and, if necessary, took in customers on credit. Garris could not be missed. He was a big man and wore a Stetson hat and a white shirt every day to work. In the old days, Garris smoked cigars. Sometimes a butt of a big cigar could been seen resting on the edge of a shelf where he had been putting up stock. Even when he stopped smoking, Garris kept a couple of Lucky Strike cigarettes in his shirt pocket and would, once in a while, take out one, look at it, put it in his mouth briefly, and then put it back it his pocket. He never started smoking again. His daughter Mary Ann, an officer with the Fairfield Genealogical Society, remembers her pop: "He was a good family man and a well-respected business owner in Fairfield County."

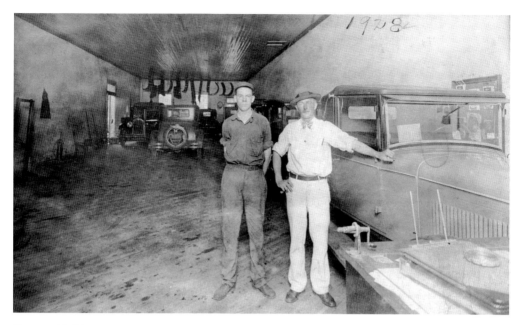

Spence McMaster

McMaster started his dealership, the Ford Place, in the 1920s. The storefront located on Main Street in downtown Winnsboro was also equipped for auto repair. The McMaster family was in the oil business, and Spence McMaster was a well-loved businessman in Winnsboro. One of his business partners was Tom Ruff. This picture was taken in 1928. McMaster (right) and an unidentified man show off their auto repair shop.

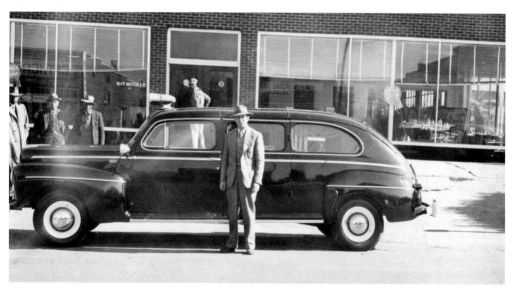

Tom Ruff

Pictured is Tom Ruff of Winnsboro Motors in the 1940s. Ruff started out in the road construction business. However, during one government bid, he fell short. Since he loved to tinker with anything mechanical, he decided to go into the automobile and oil business with his friend Spence McMaster. He bought out McMaster and become the sole owner of the car dealership in downtown Winnsboro.

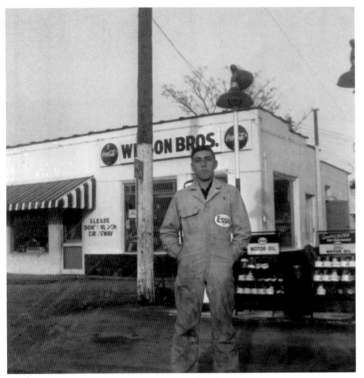

Hyram Wilson's Gulf Oil Station

Hyram Wilson always had a big smile and sometimes a cigar butt hanging from his mouth. The Wilson Station was next to Dawdy Park in the Winnsboro Mill Village area. Preston—"Pres" to local folks—and his son Hyram were popular, especially with the mill workers and teens. Some even got gas, tires, and cigarettes on credit.

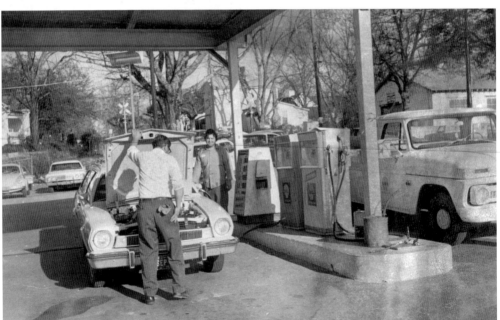

Billy Knight's Shell Station

Back in the 1940s and 1950s, gas stations were full service. Billy Knight's Shell gas station was a popular spot in downtown Winnsboro. He could be found filling a tank or under a hood, always with a rag hanging out of his back pocket. Other gas stations in town included Pope's Esso and Wilson's Gulf Oil.

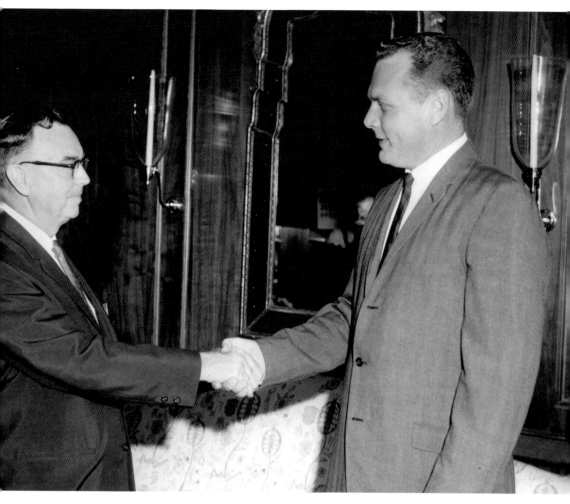

John Lawrence Pope

Everyone in the town of Winnsboro knows Pope's Funeral Home. Not just for the obvious reason, but because John Pope was a friendly, kind, and giving man. He was very active in the community and was especially fond of the young people in Winnsboro. Sadly, his only daughter, Linda, was killed in a car accident, but John and his wife, Betty, continued running the funeral home with grace and dignity. John started out working at Paschal's Funeral Home in Columbia before he moved back to his home in Winnsboro. John was also known as a jokester and one of his favorite sayings was "Yep, I will be the last man to ever let you down." His widow, Betty, still runs the funeral home. Here, from left to right, Rudy Harrington, an executive from the local Uniroyal mill, shakes hands with Pope. Harrington and Pope collaborated on many fundraising events in the community.

John Nicholson, Manager of the Western Auto
Nicholson served in World War II and came back to Fairfield County to work as the manager of the Western Auto store in downtown Winnsboro. These were the days before Walmarts and strip malls, when customer service was a part of shopping. Nicholson loved serving the town and his customers. He is pictured helping Claudia Cathcart and her two children choose a hobby horse in the 1960s.

Clyde Varnadore
Clyde worked with Jim Frazier and Marion Coleman in a small engine shop in Winnsboro. They catered to the farming and business community of rural Fairfield County. Here, Clyde (right) receives a sales award from a McCulloch Manufacturing representative. Paulette Lewis remembers Clyde as a kind and clever man. She said, "He brought us a pony in the back seat of his car. He and Wilbur Amerson made some kind of deal with my dad to get us this pony. We named her Nelly and had her for a long time." Clyde died of lung cancer at the age of 69.

BioJoe

Joe "BioJoe" Renwick was looking for a solution to the high price of diesel fuel for his truck. He teamed up with a fellow Citadel graduate to open a green fuel company called Midlands Biofuels. The main headquarters is located in Winnsboro, and it utilizes the 250GPM—the only Biodiesel Blending Skid of its kind in the Southeast. The mission of Midlands Biofuels is to increase the availability of alternative fuels in South Carolina and create sustainable green jobs in the biofuels industry. Joe has been accredited as an SC Steps to STEM Mentor and an Apprenticeship Carolina Mentor, serving on the first green apprenticeship program in the state. A second biofuels processing location was built exclusively to service US Food, one of the largest food suppliers in the nation. Midlands Biofuels now employs more than 15 people and produces over 100,000 gallons of fuel feedstock per month.

Joe comes from a long line of entrepreneurial Renwicks. In 1946, Harold Renwick, Joe's grandfather, moved to Winnsboro and started Renwick Recapping Tire Service. He then opened Renwick Pontiac Dealership in 1961 and, later, Renwick Variety Store downtown. Harold's son Erwin took over the store and in 1984 opened Renwick Office Supply and Custom Framing. Erwin invented a material used in restoring ornate picture frames. The store was eventually sold, and Erwin, also known as "Mr. Fix It," is now the mechanical operations manager at Midlands Biofuels. (Author's collection.)

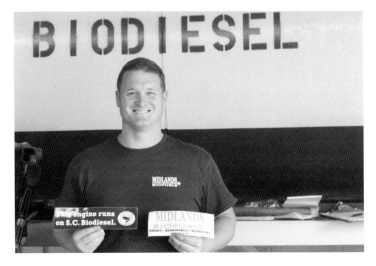

Faye Johnson

Faye Johnson walked into the *Fairfield Independent* newspaper office to put an advertisement in the paper and walked out with a job. She worked for the *Independent* for over 20 years and "loved every minute of it," Faye said. "You never knew who was going to walk in the door . . . from the long-standing Gov. Strom Thurmond to one of the colorful characters that wandered Congress Street in downtown Winnsboro. In those days, we did everything from the copy to the printing. We had a large staff that included professional printers. Our old-time printing machine was in the back room and when we finished the reporting, we went to printing." In this picture, the *Fairfield Independent* staff poses in front of the office c. 1979. Editor Faye Johnson is the fourth person to the right of the sign. Faye is now retired and lives in the historic section of Winnsboro. She continues to write.

Mike Hinnant

Mike Hinnant was employed as a firefighter in Winnsboro for 64 years, since he was 18. He drove fire trucks until he was 70 and was an active firefighter until 79. Hinnant also worked for many years as the county bailiff and owned his own blacksmith business. Firefighter Hinnant was known as "Mr. Mike." He was honored by the Winnsboro Department of Public Safety on his 82nd birthday.

Jimmie "Q Ball" Branham

In a sandpit behind Steven Greene Baptist Church, Q Ball Branham, pictured around 1950, throws a horseshoe. During those days, marbles, billiards, and ping-pong championships were very popular, and Q Ball proved worthy of his name. In 1950, he won the runner-up award in the junior division of the state marbles tournament. The contest was sponsored by the South Carolina Recreational Society and the by the Veterans of Foreign Wars.

William Waters

William Waters and Bailey Looper were hired to help construct the cotton mill village, which consisted of employee housing, an inn, and a community center. Waters was later employed at the Uniroyal mill and is pictured here (left) around 1950. The Waters family, one of the largest families in the Winnsboro Mill Village area, owes William for helping to populate the county. The love story started in 1909 when William asked for the hand of his beloved Corrie Lee Smith, age 16. Papa Daniel Smith chased off the young man, or at least that is what he thought. Corrie Lee and William eloped with the help of William's father, Thomas the ferryman, who whisked the young couple safely across the Saluda River ahead of Daniel, who was on the only horse left at the house, the slow horse. After they married at the Methodist church, the couple hid until the angry father had come and gone. The Waters moved a few miles east to Winnsboro in 1933 and both worked at the Uniroyal mill for the rest of their lives. In 1950, Corrie Lee was chosen as Winnsboro Mill Village's "Mother of the Year." While keeping house and working full time, she raised 12 children and later had 25 grandchildren. Corrie Lee and William contributed to a good portion of the population to Winnsboro Mill Village and Fairfield County, as well as standards of hard work, church, family—and most of all—young love.

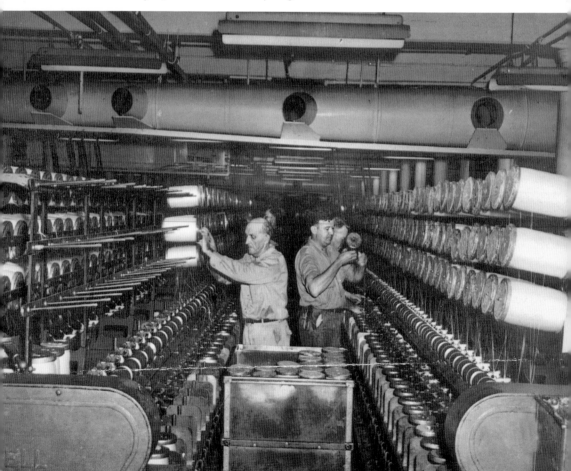

Robert Fort

Robert Fort was an employee of the United States Rubber Company (later called Uniroyal) for more than 36 years, serving the last 15 years as plant manager. He was well loved in Fairfield County. He was a Sunday school teacher at First Methodist Church of Winnsboro, an active member of the Fairfield County Recreation Association, president of United Way, director of the Fairfield Chamber of Commerce, and president of the Winnsboro Rotary Club. He retired in 1974 and passed away at the age of 72. In this photograph, from left to right, Robert, an unidentified employee, and Harold Jones celebrate an anniversary.

Tim Wilkes

A state representative from Fairfield County, Wilkes is a legend for many reasons. In 1990, the FBI conducted a sting by the code name Operation Lost Trust, the largest public legislative corruption sting in US history. The "Fat and Ugly Caucus," a group of corrupt lawmakers, was accused of bribery and conspiracy to commit fraud. Wilkes was indicted and the last to be tried. He was the only lawmaker to be exonerated. Wilkes, also a CPA and real estate developer, retired from politics in the late 1990s and pursued his true love—antique collecting. He recently appeared on the television program *American Pickers*. As a poor boy, Wilkes started collecting and selling dispensary bottles to survive and later paid his way through college. With an eye for collectors' items, he has multiple storage facilities in Winnsboro. He plans to open an antique mall, art gallery, and book emporium in the near future. Picture below, behind the counter, Wilkes shows a piece of Hitler silver to Pelham Lyles, director of the Fairfield County Historical Museum, during a special pottery and silver exhibit. (Author's collection.)

Richard "Red" H. Burton (1917–2007)

Burton, a Clemson graduate in textile engineering, was recruited by the United States Rubber Company (Uniroyal) and served as the plant manager both in the Winnsboro, South Carolina, and Gastonia, North Carolina, facilities. He was well loved during his 40-plus years working for the mill. Burton also was active in community activities, serving as president of the Jaycees, Rotary Club, chamber of commerce, and Winnsboro Cotillion. He pledged time on the Fairfield Board of Education and served as a board member of the Community Federal Savings and Loan Bank in Winnsboro for 12 years. Burton was also a member of the Winnsboro town council for 14 years and served as mayor pro tem and interim town manager when needed. Richard Burton was the first chairman of the Fairfield County Red Cross Blood Bank. In this photograph, from left to right, Russell Kerr, Mayor Bill Haslett, an unidentified man, and Richard "Red" Burton present a donation to the church.

Natalie Adams Pope

Natalie Pope is part of an all-women small business called New South Associates, which provides nationwide cultural resources and management services. She is currently vice president in charge of archaeology and the branch manager of the Columbia office. Pope develops proposals for projects, is a contact for clients and agencies, and keeps up to date with issues and information specific to South Carolina. As the principal investigator, she oversees the work of archeologists and manages report findings and evaluations. She received a bachelor of arts degree in anthropology and history from the University of North Carolina at Greensboro and her master's degree in public service archaeology from the University of South Carolina. She is a registered professional archaeologist with more than 19 years of professional experience in the Southeast and has been with New South Associates for 14 years. Pope has published numerous technical reports, cultural resource management plans, and other documents including articles in archeology journals and books. She is a member of the Society for Historical Archaeology, the Southeastern Archaeological Conference, the Southern Historical Association, the Archaeological Society of South Carolina, and the South Carolina African American Heritage Commission. She is a former president of the Council of South Carolina Professional Archaeologists and the South Carolina State Review Board for the National Register of Historic Places and is the current editor of *South Carolina Antiquities*. In her spare time, she plays music and helps her husband, Carroll Lewis Pope Jr., manage Red Hand Farm. Above, Pope is at Hampton Plantation excavating a 19th-century teapot. She is also pictured with (from left to right) Carl Steen, Dr. Stanley South, and David Jones. Pope and her partners were responsible for organizing the first Southeastern Conference on Historic Site Archaeology at the Charles Towne Landing State Historic Site. The conference honored Dr. Stanley A. South (emeritus professor, University of South Carolina), known as the "Father of Historical Archaeology" in the Southeast.

CHAPTER FIVE

Politicians and Business Leaders

Fairfield County is no longer a quiet little village. From the very beginning, immigrants came to this area to make a home and to forge on. From these early settlers came a desire to protect family and possessions, uphold the law, and build and progress. This included Thomas Woodward, lawyer turned planter, military man, and lawyer; Colonel Rion, a successful farmer; the McMasters, petroleum shareholders; the Browns, politicians and railroad executives; and many other leaders and business legends. Fairfield County had and still has a legacy of movers and shakers, people who made a difference within the community. Even today, many of the early families still have relations within the political arena such as the Lyles, Browns, McMasters, Colemans, and Palmers.

Sen. James Lyles came into politics in a big way. He paved the way for his friend and sometimes partner Strom Thurman, who went on to be the longest-serving dean of the Senate in American history and the oldest and longest-serving senator (although he was later surpassed in the latter by Robert Byrd). Politicians fought for recreational facilities, health care support, fair taxes, and budgets. Politicians such as Benjamin Hornsby Sr., Sen. John Martin, Boyd and Walter Brown, Tim Wilkes, Crosby Lewis, and Rep. Thomas Gettys worked to make Fairfield County a better place.

Business leaders included some of the early families who started shops, saw opportunities in industries such as oil and transportation, and wanted to help heal people. Business leaders included the McMasters, Popes, Rions, McCreights, Ruffs, and others. Doctors came to the town and opened medical offices before health insurance came into the picture. These tireless, heartfelt men saw patients day and night, many times going down bumpy roads in beat-up automobiles or sometimes taking the family horse or mule to the patient's house. These doctors often traded their services for eggs, chickens, a hot meal, or an IOU. Doctors like McCants, Buchanan, Turner, Bryson and more blazed a trail for the opening of the Fairfield County Hospital and, eventually, the rehabilitation center.

Progress came quickly when leaders took advantage of natural resources and started businesses such as the quarries, railroad, and mills. Fairfield County, blessed with many local waterways and the ability to transport products, was a hub for business and farming. Many academic-minded young men had the opportunity to attend the famous Mount Zion Institute, located in downtown Winnsboro, which became one of the major schools for young men in South Carolina during the 1800s. This enhanced the professional quality of graduates who decided to stay in this area after graduation. What makes Fairfield County is its people—strong, caring, and ambitious trailblazers.

Benjamin Hornsby Sr.
Hornsby, born in 1915 and presumably named for Benjamin Franklin, also came from a long line of early Fairfield County families. He served in the Air Force during World War II and further represented Fairfield County by serving in the South Carolina Senate and House of Representatives. Hornsby also worked with the Fairfield County Council and the Fairfield County State Executive Committee. He was active in recreational and community activities, making possible the opening of the local Lake Wateree State Park. Proud of his genealogy, Hornsby was a big part of the county historical society, as is his son Benjamin Hornsby Jr. Here, Benjamin Sr. is being sworn into the state Senate office in 1961. (Courtesy of Benjamin Hornsby Jr.)

Sen. John Martin (OPPOSITE PAGE)
Martin served the people of Fairfield County by representing them in the Senate for more than 35 years. He also served in the House of Representatives for two years, was chairman of the Banking and Insurance Committee, and was second in Senate seniority. In May 2007, Senator Martin received the Order of the Palmetto, the highest award that a citizen of South Carolina can be awarded. "He was a true Southern gentleman," stated Wanda Marthers, his law secretary. The senator had an open-door policy and would make time for everyone, even if it meant missing lunch or a weekend golf game. Martin was married to Mary McMaster Boulware, and they had four children. The well-loved Fairfieldian had many friends, including fellow politicians Boyd and Walter Brown. The trio purchased houses near each other, close to the historic Mount Zion Institute. They belonged to the country club and played golf together in their spare time. Martin was also active in his church, Bethel ARP, where he served as a deacon, elder, and congressional chairman. He was a big man and left big shoes to fill. "There aren't too many lawyers like Senator Martin anymore," stated Marthers. In the top photograph, Senator Martin is being sworn into office as his wife, Mary Boulware Martin, and his two children, Bosie and Marianne, look on. Shown in the bottom photograph, Sen. John Martin talks to other politicians about a Georgetown, South Carolina, collaborative program. Pictured are, from left to right, Purvis Collins, Senator Martin, South Carolina governor Fritz Hollings, and attorney James B. Moore.

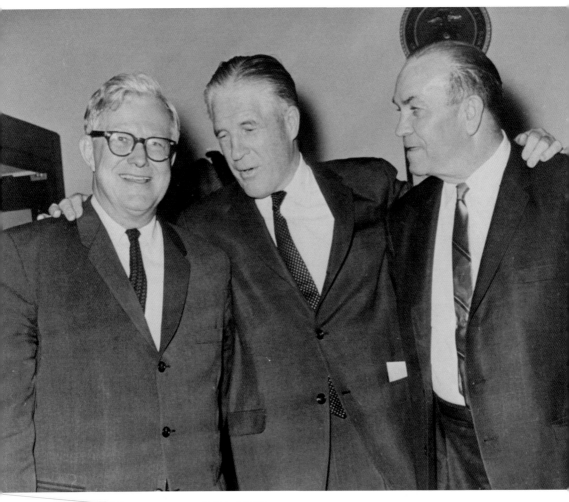

Thomas Smithwick Gettys (1912–2003)

Gettys, a South Carolina 5th District congressman, served 10 years representing Fairfield County in Washington. He attended Clemson University and Erskine College and did graduate work at Duke University and Winthrop College. Gettys volunteered to go into the Navy after the bombing of Pearl Harbor. He would often be heard saying, "Admiral Nimitz and I did all right over there in the Pacific." Gettys was an educator and working man. He studied at night to get his law degree and passed the board. Wanting to help people, he went into politics via a special election to fill the vacancy caused by the resignation of Rep. Robert W. Hemphill. He was for the people in Washington and at home. The congressman was pivotal in creating a Medicaid program in South Carolina. Gettys was very involved in civic programs, especially in his hometown of Rock Hill. "He was a great teaser," said Sen. Ernest Hollings, "and he often would catch people by surprise by asking if they enjoyed the casserole he sent. When told that, no, they had not gotten a casserole, Gettys would respond, 'Well, I left it on the porch. The dogs must have gotten it.'" Hollings added, "The man who went to Washington was the same man when he came home." In this photograph are, from left to right, unidentified, George Romney (father of Mitt Romney), and Congressman Thomas Gettys.

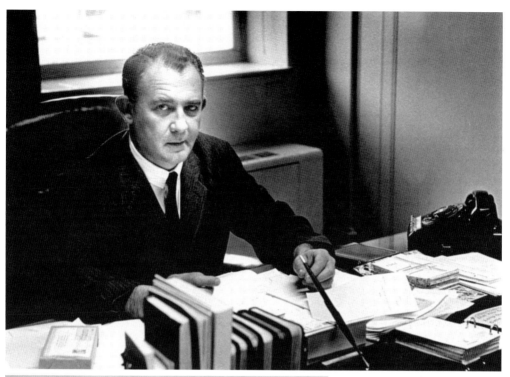

Walter B. Brown

This South Carolina politician and businessman was a member of the House of Representatives, the first director of the South Carolina Department of General Services (now the Budget and Control Board), vice president for Government Affairs of Norfolk Southern Corporation (formerly Southern Railroad), and the first trustee emeritus at the Medical University of South Carolina. Walter Boyd Brown Industrial Park in Fairfield County is named in his honor. His son David served on the Fairfield County Council, and his grandson H. Boyd Brown served as a member of the South Carolina House of Representatives. Pictured above is Brown in his office. Shown at left, Brown is socializing at the country club.

Fritz Creighton McMaster

McMaster (right) grew up in Winnsboro and attended Mount Zion Institute. A Duke University graduate, he was hailed as an outstanding athlete and businessman. Second Lieutenant McMaster was also a platoon commander in the 1st Marine Division in the Korean War and later in the 89th Special Infantry Company. He served in the US Marine Corps Reserves until 1955. McMaster joined his father in the family's petroleum marketing operations and retired as president of Winnsboro Petroleum Company. He was also president of the South Carolina Petroleum Marketers Association and the South Carolina Oil Fuel Institute, and he served as state director of the National Petroleum Marketers Association. McMaster was director of SCANA Corporation and the head of many banks in Fairfield County. He was recognized as a political leader through his longtime service in Fairfield County.

Dr. James Bryson
Dr. James Bryson worked as the director of the department of health. His office was in the basement of the courthouse. Part of his duties was to oversee the medical care of the "village people." Pictured below, a young man gets his teeth cleaned at Everett Elementary School. Dr. Bryson (right) assists an unidentified nurse while Principal Earl Turner (center) observes.

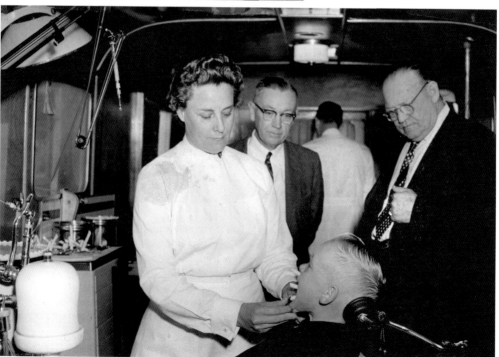

Dr. J.B. Floyd (1913–1987)
Floyd was a very special doctor and citizen of Fairfield County. He enjoyed life to the fullest, from activities within his church to "watching things grow." People of Winnsboro have many great memories of this family doctor. "He was a great man. His warmth, compassion and love for his patients were barely hidden beneath his gruff nature. While his appearance was imposing, he was a great big teddy bear below the surface," said Dianne Arnette. From birthing babies to stitching up fishing buddies, Dr. J.B. Floyd will be always remembered (and missed) in Fairfield County. (Courtesy of the Floyd family.)

Dr. Charles Spencer McCants

Dr. McCants began his practice in 1918. During that time in Fairfield County, rural medicine consisted of a lot of house calls and country travels. Both he and Dr. John Buchanan were instrumental in getting Fairfield Memorial Hospital started and both served as chief of staff and chairman of the board during their years of practice. There was no insurance so the individual was responsible for the bill. "It was $1 for an office visit and $2 for a house call. Extra mileage fee ran about $2 a mile and a baby delivery was $25," McCants said during a newspaper interview in 1986. "I delivered at least 3,500 babies so far in my practice, but to tell you the truth I lost count. Sometimes we got a half of dozen eggs to deliver a girl and a full dozen if it was a boy," McCants said proudly. The doctor practiced until he was 96 years old, making him the oldest practitioner in the state. Above is a photograph of Charles Spencer and Isabell Gooding McCants celebrating their 50th wedding anniversary in the 1970s.

Dr. John Creighton Buchanan Jr.

Dr. Buchanan joined three other general medicine doctors right before the Great Depression in 1929. Even though he was officially located in the town of Winnsboro, the doctors did what they needed to do to service the community, which many times included house calls. "We had offices, but we didn't have regular office hours," said Dr. Buchanan in an interview for the *Herald Independent* in 2006. "If we had patients that needed hospitalization, we put them on a train and sent them to Columbia or Chester." Dr. Buchanan's longtime nurse Virginia McFadden recalled, "Dr. Buchanan's life was medicine." He was giving anesthesia to patients at only 12 or 13 years old when he helped his father, Dr. John Buchanan Sr. McFadden detailed a typical day with the doctor as follows: "We would leave the office at six o'clock and go toward Ridgeway, Lugoff, Elgin and all down in there, and then we would come back into town and get a bite of supper and go the other way toward Blair." Dr. Buchanan also did banking on the side and was president of the Bank of Ridgeway for many years and the director of Community Federal and Bank of Fairfield. He also served as chief of staff and chairman of the hospital board during his medical practice in Fairfield County. He closed his office doors in June 1986. The Buchanan-McCants Rehabilitation Center is named is his honor. Here, Buchanan poses with other board members of the Fairfield County Hospital. From left to right are (first row) Dr. Allen Jeter, Dr. Frank Culbertson, and Dr. J.B. Floyd; (second row) John Buchanan, Billy Lyles, Spencer McCants, and Dr. James Turner.

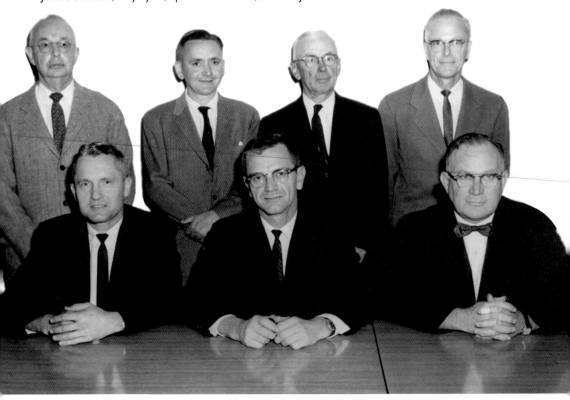

CHAPTER SIX

The Community

The people of Fairfield County represent a community of sharing and giving. They embody "Southern hospitality." The law and government have provided stability and protection for citizens ever since the Regulators took it upon themselves to secure the population against bandits. Even during vigilante attacks, caretakers of the town sometimes put themselves in harm's way to preserve the law. Some say the Winnsboro massacre, which left a Fairfield County sheriff and deputy dead, sparked the civil rights movement. The sheriff and police department has come a long way from chasing down mobster bootleggers but still continues to tear down homemade stills and protect citizens in their homes, schools, and churches. Fairfield County has transformed from a segregated community to a blend of races, cultures, traditions, and values. The local law enforcement interacts with all people. Firefighters have also progressed by securing modern equipment and providing advanced medical services.

In Fairfield County, social time is important, whether it is in church or other organizations; local people visit and help each other. The chamber of commerce is a great driving force that conducts events, festivals, and contests. Beauty contests are very popular as well as art and music festivals. Miriam Stevenson made Fairfield County proud when she was crowned both Miss USA and Miss Universe in 1954. The Winnsboro Downtown Association regularly shows off merchants and historic buildings during socials such as movie nights, the Rock around the Clock Festival, or the New Harmonies Music Festival. The Arts on the Ridge and the Pig on the Ridge festivals take place in Ridgeway, during which Fairfield residents get to show off their artistic, musical, and culinary talents.

Music is a part of the culture in Fairfield County. From the mountain hillbilly sounds to the South Carolina shag, there is always an opportunity to hear music and dance in the streets. Fairfieldians have music in their genes—from Nellie McMaster Sprott to the Blackstock Bluegrass music emporium. The 145 Club brings new and old South Carolina talent to town, including Drink Small, Susan Douglass Taylor, John Hartness, and others. Local artists, such as educator and art-award winner Katrina Hampton, enjoy mentoring children, and organizations like the Fairfield Arts Association help sponsor these art programs. Other famous artists include Laura Glenn Douglas, Russell Henderson, Bill Taylor, and international airbrush artist and educator Dru Blair. The woman's club, which has been around since the early 1900s, also conducts club meetings and sponsors events such as the Home Show and the Ghost Walk. Schools offer many extracurricular activities like sporting events, music, drama, art, and quiz shows.

Some famous athletes had their beginnings as stars in local schools and organizations. Famous African American female baseball player Peanut Johnson, from Ridgeway, horse jockey Gil Glisson, and NFL star Tyler Thigpen all hailed from Fairfield County. The community is a diverse group of people that has banded together to help each other and share resources, risks, values, cultural visions, and heritage to become a cohesive but individualized people. Fairfield County is a great place to live.

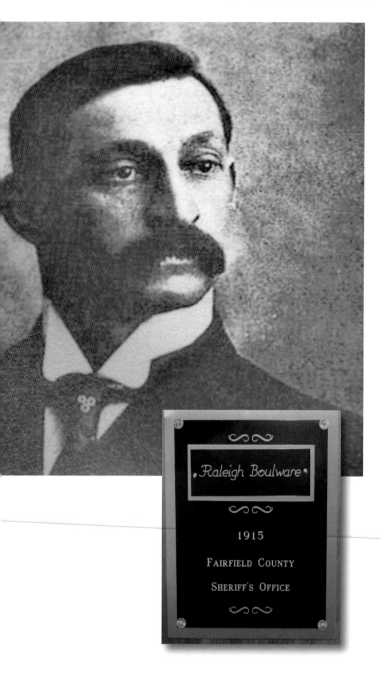

Sheriff Adam Dubard Hood and Deputy Raleigh Boulware
The Winnsboro massacre of 1915 was so named because it was one of the bloodiest events, outside of war, within Fairfield County. Sheriff A.D. Hood and Deputy Raleigh Boulware were brutally shot and killed by vigilantes on the steps of the Fairfield County Courthouse when they were trying to escort a black prisoner into a courtroom. Jules Smith, who was accused of a crime against a white woman, was also shot and killed. Eyewitness reports of the massacre state that Boulware was unnecessarily fired upon even after the prisoner and Hood were inside the courtroom doors. Boulware died several days later from the injuries. Hood and Smith died almost immediately. A photograph of Sheriff A.D. Hood (shown here) can be found in the South Carolina Law Enforcement Officers' Hall of Fame in Columbia, South Carolina. At left, a plaque honoring Deputy Boulware is also on display at the museum. (Both, courtesy of Virginia Schafer.)

Fairfield Law Enforcement (OPPOSITE PAGE, BOTTOM)
Police department officers and jailers from Winnsboro pose for a photograph in the 1960s. From left to right are Robert W. Brooks, Bob Wilson, Scoop Carey, Son Parrish, Woodward Hollis, Marvin Bankhead, and Jack Robinson. Scoop Carey, a bailiff for Fairfield County, lived in the old Royal Hotel. He was thought to be a member of a secret organization and had some interesting tales to tell. Some said they were tall tales, but others swore the stories about Bailiff Carey were indeed true.

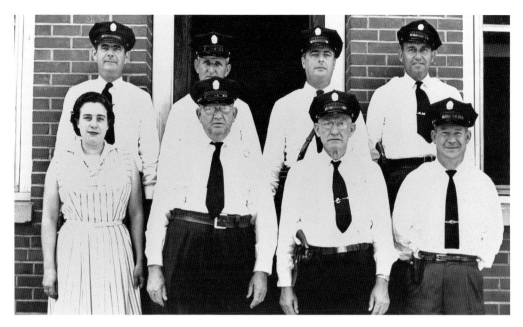

Rice MacFie

On June 8, 1953, Fairfield County police officers posed for a picture. From left to right are (first row) Blanch Roberston, Moses Cathcart, Bob Boulware, and Skippy Brown; (second row) Rice MacFie, Gene Gladdon, Roy Montgomery, and Hook Stevenson. Rice MacFie was an intrepid police officer. During the early years of the 1930s and 1940s, MacFie would jump onto the sideboards on the Fairfield County police vehicle, an old broken down Model-T Ford, to chase bad guys. Even though the automobile was small and slow and often had to be pushed, the brave officers would chase Chicago mafia mobsters who came to collect and redistribute local moonshine. The Fairfield County Police Department captured many mobster vehicles and took them to McMaster's Ford Dealership where bootleg whiskey was usually found hidden in secret compartments in the cars.

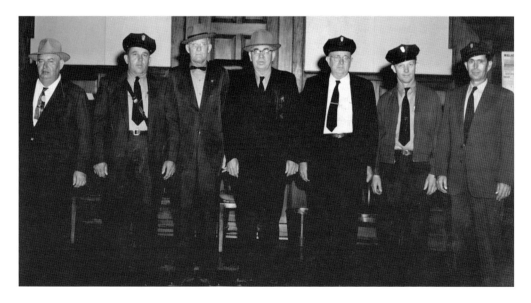

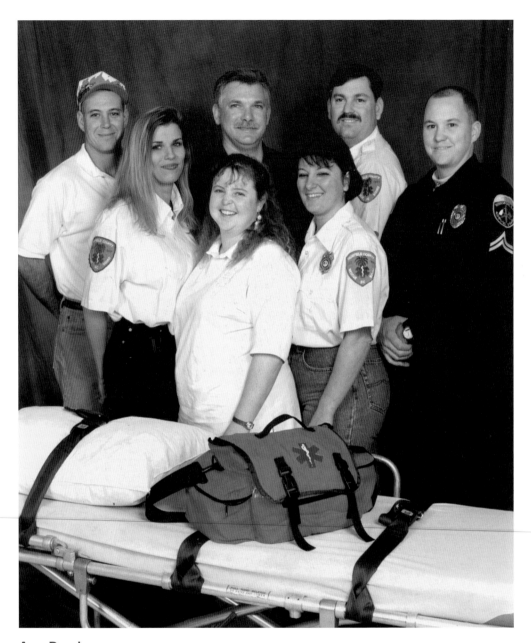

Amy Douglas
In 1971, the first active fire station in Fairfield County was born. Winnsboro Mill Village was the first community fire department. Fairfield County Fire Board was later formed to coordinate it, and other fire stations in Fairfield County soon followed. By 1997, there were 11 stations to serve the county. Amy Douglas, mother of two and wife of military hero Kevin Douglas, was the first female in the community's fire department. She was also the first female on the Fairfield County Fire Board and the first female chairperson. Here, Amy is pictured with other volunteers in the Fairfield Fire Department/ Rescue Squad. Pictured are, (first row) Amy Douglas; (second row) Crystal Armstrong and Maggie Bade Ferguson; (third row) Kevin Douglas, Mike Hollis and Eric Cathcart, and William Gonzales. (Courtesy of Amy Douglas.)

Quay Williford McMaster

Quay McMaster was a Winnsboro icon. Not only was McMaster an entrepreneur extraordinaire but he also held the distinction of being the longest serving mayor in Winnsboro's history. He was also one of the longest-serving mayors in the state of South Carolina. According to a special publication in honor of McMaster's retirement after 30 years of service, the numbers served McMaster: the *Herald Independent* figured that Quay McMaster spent 12,480 hours as mayor; approved more than $9 million in budgets; cut over 1,800 feet of ribbon at grand openings; spent 1,440 hours at town council meetings; sanctioned at least 200 new businesses; and ate 120 helpings of chicken, macaroni and cheese, and green beans at special events. The well-loved Quay McMaster passed away at age 83.

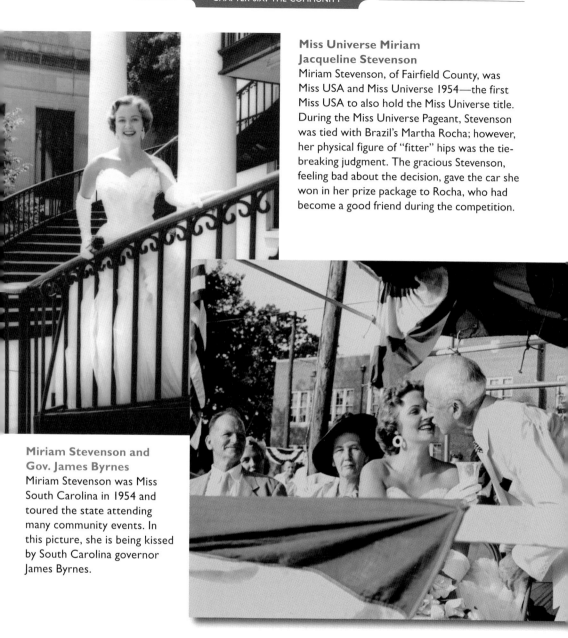

Miss Universe Miriam Jacqueline Stevenson

Miriam Stevenson, of Fairfield County, was Miss USA and Miss Universe 1954—the first Miss USA to also hold the Miss Universe title. During the Miss Universe Pageant, Stevenson was tied with Brazil's Martha Rocha; however, her physical figure of "fitter" hips was the tie-breaking judgment. The gracious Stevenson, feeling bad about the decision, gave the car she won in her prize package to Rocha, who had become a good friend during the competition.

Miriam Stevenson and Gov. James Byrnes

Miriam Stevenson was Miss South Carolina in 1954 and toured the state attending many community events. In this picture, she is being kissed by South Carolina governor James Byrnes.

Sheriff Herman W. Young (OPPOSITE PAGE)

Herman Young, born and raised in Blair, has been the Fairfield County sheriff for over 20 years. He was recently reelected for another term. Young began his career as a police officer in New York City in 1962 and, after moving back home, worked in the Winnsboro Police Department. In 1973, he took on the position as administrator of the Fairfield County Detention Center and was elected as sheriff of Fairfield County in 1992. Young has received many distinguished awards, including the 1996 Sheriff of the Year Award, the Distinguished Service Award from the South Carolina Correctional Association, and the Hugo Service Award. He has many times been voted as Fairfield County's Elected Official, Best of the Best Award. In 2011, he was elected as president of the South Carolina Sheriffs' Association. (Courtesy of the Fairfield County Sheriff's Department.)

Officer Richard Miles
Ridgeway's jokester Dickie Mills poses as the "Ugly Bride" in a local community fundraiser. Dickie Miles had many jobs in and around Fairfield County, and one of them was to serve as a police officer in Ridgeway, which boasts the smallest police station in the world. The station measures 1-by-12 feet and was built in 1940. The building also made its movie debut in the 1989 film *Staying Together* and was an official rest stop in the Olympic Centennial Torch run. Shown below is the police station building as it stands today; it is now a self-service visitors' center with brochures and information about the town of Ridgeway and Fairfield County. (Courtesy of Katrina Marion.)

The Fairfield Chamber of Commerce The chamber of commerce was chartered in 1945, and its mission is to promote the economic development of Fairfield County and to better serve the needs of the community, its citizens, and businesses. Pictured here are, from left to right, secretary Eloise Morris and Spencer McCants (seated) and Jacks McMaster and Earnest Blair (standing) around 1960.

The Fairfield County Jaycees The Jaycees was a very popular organization in the 1970s. Its mission is to use personal and leadership skills to help the county and have a social outlet for business leaders within the community. The Jaycees award scholarships and prizes to Fairfield County's outstanding students. Pictured at the Jaycee awards are, from left to right, Coty Burton, Richard Burton, and Joel Jelks with Mayor Bill Haslet (background, seated).

The Winnsboro Woman's Club

Pictured are some members of the Winnsboro Woman's Club in the 1960s. The club has been in existence since 1919. It is part of the General Federation of Women's Club, an international organization whose mission is "to improve the communities in which they live by enhancing the lives of others through volunteer service." Heading out to a district meeting around 1960, these women are, from left to right, (first row) ? Calpine and Laverne Center; (second row) Sophie Milon, Vivian Smith, and Sadie Renwick.

Dot Hobbs

Dot Hobbs was known as the "Queen Bee" of Fairfield County, a true fashionista before her time. A staunch Republican and the epitome of a mother from the 1950s and 1960s, Dot stayed home with her two children and did volunteer work whenever needed, especially at the local private school, Richard Winn Academy. Dot and her husband, Ralph, were two of the founders of the school in 1966, and she sat on the school board for many years. Everyone in town wanted to dress like Dot. Her "bling" shoes were especially famous. Here, she is pictured doing volunteer work with other members of the board of education. They are, from left to right, Dot Hobbs, Buddy Brooks, Billy Traylor, and Johnny McLeod.

Judge Thomas Barrineau
Barrineau is the longest-serving judge from Fairfield County. He served as Fairfield County probate judge from 1969 until 1980, when he became the first 6th circuit family court judge. He retired from the bench in 1994.

The Business and Professional Women's Foundation of Fairfield County (BPW)
The Business and Professional Women's Foundation is a national nonprofit organization that focuses on issues that impact women, both in their family and work environment. Organizations such as this were groundbreaking especially in the smaller, rural communities in the 1950s and 1960s. These women were true legends. In this photograph, the Fairfield County branch of the BPW comes together for an event at the Fairfield County Hospital. Margaret Ruff, the club's representative, presents a donation to an unknown hospital administrator in the 1960s.

Mary Gail Douglas

Douglas is the first congresswoman in the South Carolina House of Representatives from Fairfield County. A graduate from the University of South Carolina School of Nursing, she was employed at Fairfield County Hospital for 13 years. Douglas worked for Fairfield County Council on Aging for 17 years and then retired. During retirement, she worked as a consultant to a software company and owned a consignment shop in Winnsboro. Congresswoman Douglas also helped develop a software system for shops with this specialty. Douglas served as president of the South Carolina Council on Aging for two terms, sat on the board of the Blue Ridge Community Executive Council, was an invitee to the National Institute on Leadership in Denver, Colorado, and served as a South Carolina ElderCare Trust Fund board member. Douglas, an active member of the First Baptist Church of Winnsboro, recently won the election for District 41 in a landslide, replacing Rep. Boyd Brown. Douglas (left) poses with chamber of commerce director Terry Vickers at Winnsboro's Cornwallis Tea Room. (Author's collection.)

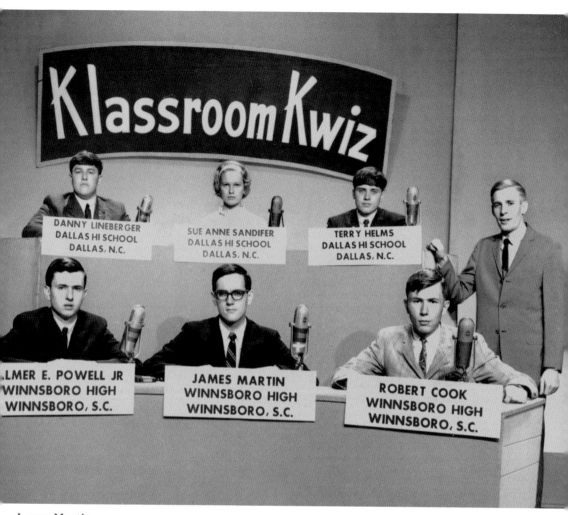

Klassroom Kwiz

DANNY LINEBERGER
DALLAS HI SCHOOL
DALLAS, N.C.

SUE ANNE SANDIFER
DALLAS HI SCHOOL
DALLAS, N.C.

TERRY HELMS
DALLAS HI SCHOOL
DALLAS, N.C.

LMER E. POWELL JR
WINNSBORO HIGH
WINNSBORO, S.C.

JAMES MARTIN
WINNSBORO HIGH
WINNSBORO, S.C.

ROBERT COOK
WINNSBORO HIGH
WINNSBORO, S.C.

James Martin

James Martin was one of Winnsboro High School's Kwiz Kids. Local high school students Palmer Powell Jr., Robert Cook, and James Martin were featured on the television show *Klassroom Kwiz*. This was a popular *Jeopardy*-type show, produced in the 1960s and 1970s. Winnsboro was in the semifinals but lost to a high school from Dallas, North Carolina, in the final moments. The students were asked general-knowledge questions on various subjects. One team consisted of three students and two alternates. There were four rounds to each game: the first round was team questions; the second round was toss-up and follow-up questions; round three was a short 60-second round, and round four was toss-up questions. *Klassroom Kwiz* was said to have originated from a Virginia radio station. The creative game show was the brainchild of the station's broadcast pioneer Hayden Huddleston. James Martin was chosen as one of the contestants because "he got the brains," said his sister Sally Martin Smith. James went on to graduate from Clemson University with a degree in mechanical engineering and now works and lives in Anderson, South Carolina. He has two sons and three grandchildren.

Negro Leagues Baseball Living Legend

Mamie Peanut Johnson
Belton Harrison

Negro Leagues Baseball only living female baseball player

MAMIE "PEANUT" JOHNSON P/2B
INDIANAPOLIS CLOWNS
1953 - 55

Mamie "Peanut" Johnson
Mamie Johnson was born on September 27, 1935, in Ridgeway. Mamie was one of the three women—and the first female pitcher—to play in the Negro Baseball League. She was nicknamed "Peanut" because she was only five feet, three inches tall. At age 19, she became a member of the Indianapolis Clowns. There, Peanut learned baseball tips from her teammates Hank Aaron and "Satchel" Paige. Johnson now runs the Negro League's Baseball Shop in Bowie, Maryland. The store specializes in hats, memorabilia, and clothes honoring Negro League stars. (Courtesy of Charlene Herring, mayor of Ridgeway, South Carolina.)

Joseph Jefferson Jackson (OPPOSITE PAGE)
Better known as "Shoeless Joe Jackson," the famous baseball player of the early 1900s coached and managed the Winnsboro Mill Royal Cords Baseball team in 1934. During that time, he was also nicknamed "Boss Jackson" and "Skipper Jackson," often for media attention. Joe Jackson, formerly of the Chicago Red Sox, was known as a "Black Sox" because of his involvement in the conspiracy to fix the World Series of 1934. Previous to his ban from baseball, Jackson held the third-highest career batting average in major league history and the sixth-highest single-season total since 1901. His father was a poor sharecropper, and Jackson grew up illiterate. He got his "Shoeless" nickname after he ditched his ill-fitting cleats and ran the bases in his socks. Joe was between business ventures when he took the job in Winnsboro, often going back and forth to his barbecue restaurant in Greenville. This barbecue café was the first restaurant to offer curb service in South Carolina. Shoeless Joe Jackson's managerial career in Winnsboro was short lived, but within two years, the Cords progressed forward and claimed the Mid-State Crown. Jackson will always be a legend in Winnsboro. (Author's collection.)

John Johnson
In the 1960s, Johnson was an all-star football player for Mount Zion Institute in Winnsboro. He played in the coveted Shrine Bowl game, the nation's oldest and most prestigious high school all-star football game. He was recruited to play for West Point Military Academy. In 1965, Johnson was commissioned as a lieutenant colonel and served two tours of duty in Vietnam. From 1970 to 1973, Johnson returned to West Point and was one of the lead coaches for the Army Black Knights football team. After retirement, the Johnsons returned to Fairfield County.

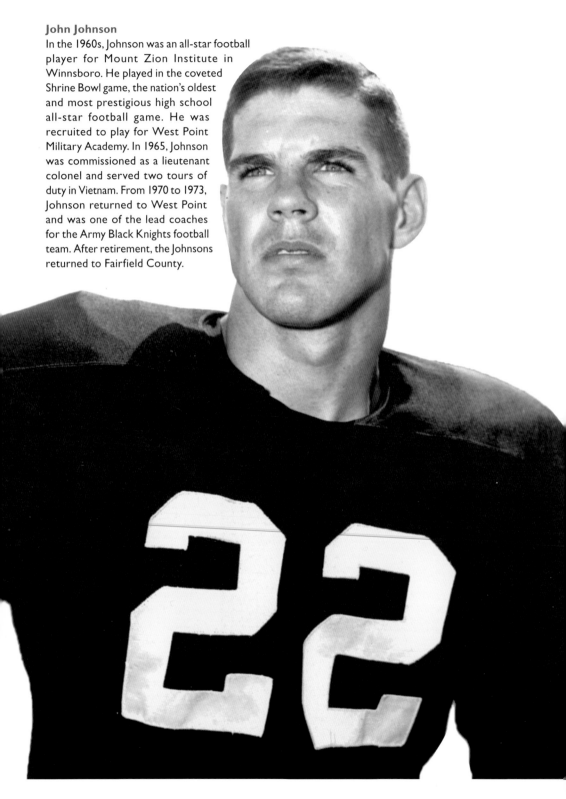

Tyler Beckham Thigpen
Tyler Beckham Thigpen is a football quarterback for the NFL, now playing for the Buffalo Bills. Thigpen was drafted from Coastal Carolina University in the seventh round of the 2007 NFL Draft by the Minnesota Vikings, then he played for the Kansas City Chiefs in 2008. He was traded to the Miami Dolphins in 2009 and, on July 26, 2011, agreed to terms to play with the Buffalo Bills. His contract was recently updated, and it was rumored that Thigpen took almost a $1-million salary cut to stay with the Bills. He was born in Winnsboro and attended Fairfield Central High School, where he played wide receiver and punter. It was here he earned the nickname "Dirty Pigpen." He was the first quarterback to play for the Coastal Carolina Chanticleers football team and led the Chanticleers program to a 30-8 record as starting quarterback. Thigpen holds the single-season and career passing records in every major statistical category at Coastal Carolina and became an all–South Carolina selection as a senior running back. Thigpen is active in Fairfield community activities and tries to contribute to worthy causes whenever possible. In 2012, Thigpen was the special guest at the "Cruising for the Cure" American Cancer Society of Fairfield County's Relay for Life fundraiser at the Nazarene Church. Thigpen was a caregiver to his mother who passed away due to cancer. "Our emphasis should not be about cancer, but about life," Thigpen said. He gives generously to his hometown of Winnsboro. (Author's collection.)

Mount Zion Girls' Basketball Team
The Mount Zion girls' basketball team was the Upper State Champions in 1929. Pictured here are, from left to right, (first row) Ella Johnson and Lizzie Elliott; (second row) Mimi Cheaton (coach), Zelma Brice, Margaret MacFie, Minnie Lee Stevenson, and Kib Cathcart.

Pelham Lyles
Pictured here, Pelham Lyles takes a break at the Fairfield Country Club tennis court in the 1970s. Pelham, who studied art in France, came home to Fairfield County to teach. Also a self-taught historian and archeological enthusiast, she was asked to take the position as director of the Fairfield County Historical Museum in 1996. She currently serves at the museum, greeting guests, planning exhibits and tours, and helping folks with genealogical and historical research.

Gordon P. Glisson (1930–1997)
Glisson was an American champion thoroughbred jockey. In 1950, he was the first recipient of the newly created George Woolf Memorial Jockey Award, which is given to a successful thoroughbred-racing jockey in North America who demonstrates high standards of personal and professional conduct, on and off the racetrack. In 2003, he was nominated for the Washington Thoroughbred Racing Hall of Fame. When he was only 18 years old, the young boy from Winnsboro ran 143 winners in his first year on the racing circuit. Glisson was discovered when he was washing dishes in a café. A professional horseman took him under his wing for an apprenticeship. Glisson died at a burn unit in Los Angeles after an accident at his home. He was only 47 but had been plagued with medical illnesses and old injuries. Glisson (far right) is pictured during a post-race interview c. 1950. (Courtesy of ACME Photo.)

Janice Bartell
Fairfield Country Club is also known for its golf course and accomplished players and teams. These Fairfield County women's golf team members are, from left to right, Theone Stocke, Pat Reigle, Fairfield Country Club pro Jim Bunting, Janice Bartell, and Joan Verrastro. Bartell went on to open a beauty salon and has had a successful clientele in Winnsboro for over 30 years. She is and has been a driving force in many local organizations, such as the woman's club, the chamber of commerce, and the Winnsboro mill reunion.

Ronnie Collins
Ronnie Collins, an accomplished athlete, is pictured here with his trophy for championship bowling in 1970. Collins earned a basketball scholarship to the University of South Carolina.

Coach Athletic Awards at Mount Zion Institute
The Mount Zion athletic banquet was held at the Mount Zion Institute in 1956. The coaches were awarded trophies in a special presentation. Pictured are, from left to right, Jack Herndon, John Powell, Bob Donaldson, Purvis Collins, and Pinkie McMaster.

Millard Smith, Fisherman
Smith, also called "Smitty," ran the Jetco Gas Station in Winnsboro for several years and fished whenever he could. Millard poses with his prize catch, a blue gill bream. This fish was reportedly caught in Ellison's pond and held the state record for many years. According to Mike Mincey, this fish was kept in the freezer for more than 10 years until "it didn't look like a fish anymore."

Ernest Pendleton Ferguson

Born in 1924, Ferguson is a photographer and postcard-maker. He started in the early 1950s with images of his hometown of Winnsboro, then went to the South Carolina coast to include the areas around Georgetown and Beaufort. Ferguson's family has been a part of the cloth of Fairfield County for many years, and Ernest was the only photographer in town for most of them. He was the photographer for the Uniroyal mill, the schools, and the newspaper. His favorite medium for his art was postcards. His early postcards, done in the mid-1950s, were his most famous and are still used by tourism boards in South Carolina. Ferguson incorporated his photograph/postcard business in the 1980s and sold to stores and cities all over the state. He was at his peak in 1989—he sold more than a million cards that year. Now, the cards are printed in North Dakota, but the photographs are from the heart. "People are buying postcards less now due to digital cameras and phones with cameras," Ferguson said. He served in the Navy and, at age 21, was assigned to a submarine unit during World War II. His rank was lieutenant, and he did two tours in the South Pacific aboard small ships and submarine chasers. After the service, he went to school at Randolf-Macon College, then on to photography school in Baltimore, Maryland. His new passion is Indian artifacts: "Really, I have been collecting arrowheads and pottery pieces for years." His collection includes Guilford and Morrow Mountain points that date to between 3,000 and 8,000 years old. These "points" are scrapers used for skinning animals among other purposes. He also has an early-American face pipe collection. Ferguson respects the history of his home and the people, especially the Indians, who came before him. Above, Ferguson and his buddies are at one of their favorite places, Georgetown, South Carolina. This fishing trip in the 1960s included, from left to right, Mark Stevens, Pat Suber, Ernest Ferguson, Charles Vickers, Albert Doty, and boat captain Joe Skinner. (Copyright 2012 *Herald Independent*. All rights reserved.)

Katrina Hampton

Katrina Hampton, educator and artist, has received many awards. Recently, she was awarded first place in the Friends of the Fairfield County Arts Award at Fairfield County's Art Festival. The yearly festival takes place in May and is held at the historic Century House, now the town hall, in the quaint town of Ridgeway. The Town of Ridgeway and the Fairfield County Arts Council sponsor the festival. The council's mission is to present a harmony of cultures through art, music, and literature. Besides the awards, other activities include the adult art exhibit, the children's art exhibit, music, and food. The 2012 winner, Katrina Hampton (center), is an art educator in the Fairfield County School District and works with the artistically gifted students in the Artwork Program. Katrina thinks outside the box and has initiated programs such as the Camera Club at Geiger Elementary School, where she is an art teacher. The students displayed their Blackstock Music Photograph Exhibit at the Arts on the Ridge Festival and during the Winnsboro New Harmonies Music Festival and the Smithsonian Main Street Traveling Show. Katrina is also a resident artist at TAPP's Art Center in Columbia, South Carolina. Pictured is Arthur Lanthan, (left), president of the Fairfield County Arts Council for 2012; Katrina Hampton; and Darwin Murphy. (Courtesy of Marilyn Murphy.)

William "Bill" Wilson Taylor

Pelham Lyles, artist and historical society volunteer, paints the face of Fairfield County Historical Museum director Bill Taylor in the 1980s. The Fairfield County Arts Festival was a collaboration between the Fairfield Arts Association, the Fairfield County Historical Museum, and other organizations within the county. Taylor, a well-known artist, moved to Fairfield County to be close to his wife's family. He then took the position as the first museum director and jumped right into the community organizing events. He mentored his close friend and fellow artist Pelham Lyles to take over as the director of the Fairfield County Historical Museum when he retired and moved to Florida. Taylor spent most of his life in the commercial-art business and public relations. He also worked as a writer for Scripps-Howard publishing company and the US Information Agency and ran his own film studio. Taylor studied art at the Ringling College of Art and Design in Sarasota, Florida, and at the American University in Washington, DC, and finally landed up at the University of South Carolina. When Taylor was ready to retire in 1975, it was easy for him to take the job at the museum and write a weekly newspaper column. However, after a few years, the artist in him was calling, and the Taylors moved to the art town of Mount Dora, Florida. Taylor again became active in the community, joining the chamber of commerce and the library board. He continued to scratch his artist itch by opening a studio in the Mount Dora Art District. Sadly, the well-loved artist and community leader passed away a few years later at the age of 78. Taylor was a legend wherever he lived.

Volley McKenzie
Music festivals have always been popular in Fairfield County. Here, Volley McKenzie, left, performs bluegrass music on the backstage of the Fairfield County Historical Museum during Hootenanny 1979. Volley is a well-known musician and songwriter now residing in Asheville, North Carolina. He enjoyed growing up in Winnsboro. He comes back often to play at church fundraisers or other community events.

Robert Kinard
In the mid-1990s, Robert Kinard, an art teacher at Fairfield Central High School, received the National Art Education Standards Award. Kinard went on to teach at South Carolina Governor's School for the Arts and Humanities, an honor and a reflection of the hard work that he had put in as an artist and teacher. He inspired many students in Fairfield County within the school system and through his volunteer activities. In this photograph, Kinard shows off his student's award-winning work at a museum art show in the 1980s.

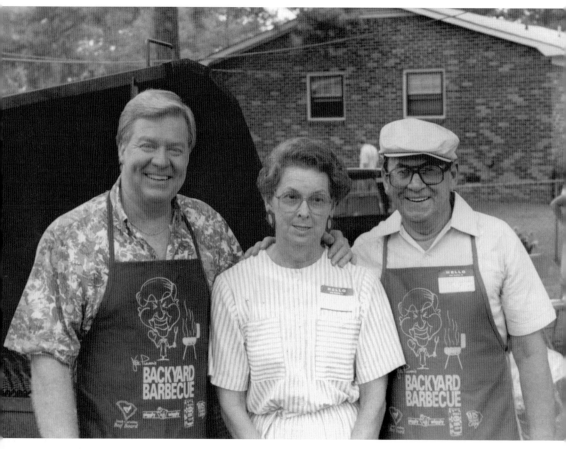

Joe Pinner

Joe Pinner, television and radio personality, is active in promoting his adopted hometown of Blythewood. Blythewood, which currently lies on the Richland-Fairfield county line, holds many festivals and art events, and, usually, Pinner is right up front. He is known as the "king of master of ceremonies." He has been with WIS-TV station in Columbia since 1963. Most recently, his work has centered on public appearances and many volunteer activities. The Midlands's famous television personality has accumulated many awards throughout his career, including the George Foster Peabody Award and the South Carolina Tourism Award. Here, Pinner is part of the judging team during the Pigs on the Ridge Festival in Ridgeway. This barbecue cook-off takes place the first weekend of November and is one of the largest barbecue cook-offs in South Carolina. Pictured from left to right, Pinner poses with the 1980 winners, Eileen and Tip Fowler.

Carolina Artist's Heritage
BY KATHLEEN LEWIS SLOAN

Russell Henderson (1890–1961)

Henderson was born on his grandfather's plantation, attended Duke University, and traveled and worked as an illustrator for many publications throughout the United States. He eventually came back to South Carolina and called Winnsboro his adopted home. Henderson was nationally known as a folklorist and artist. His especially liked to illustrate rural life in the Carolinas. The highly talented artist was known for his meticulous draftsmanship and colorful cartoon interpretation of Southern characters and country landscapes. Henderson always said that his duty was to make people happy. One story told about the scrawny man is about golf. When standing on the green getting ready to putt, a ball came out of nowhere and fell at Henderson's feet a few inches from the cup. He smiled and nudged it into the cup, and when the golfer came looking for his ball, Henderson declared that he made a hole in one. Later, Henderson's golfing companion asked him why he did that, and he replied, "Well, I made him happy." Henderson worked in advertising. He is said to have coined the Chesterfield cigarette slogan "They satisfy," which was befitting to the man who always had a cigarette hanging from his mouth. Other jobs included illustrator for the *Ladies Home Journal*, the *Country Gentleman*, and *Life*. In his later years, he worked for the local *State* newspaper and *Ford Times*. A fellow artist described Henderson as "an artist who did with pictures what Joel Chandler Harris did with words." Henderson passed away in Winnsboro after many years of a debilitating illness. His epitaph reads, "I hereby bequeath upon each of you an abundance of smiles—spend freely."

Elfi Hacker
Originally from Austria, this enterprising businesswoman brought her major production company, Hacker Instruments and Industries, Inc., from New Jersey to South Carolina in 2004. Elfi later sold the company and ventured into a project dear to her heart—music. She opened the 145 Club in downtown Winnsboro, which is a private music and dance club that focuses on Americana music, jazz, and blues. The club showcases local musicians. She is very active in Winnsboro's downtown revitalization. In this photograph, Elfi, master of ceremonies, introduces the musical guests at the First Annual New Harmonies Music Festival in 2012. (Author's collection.)

Drink Small, Blues Artist
Drink Small, also known as the "Blue's Doctor," is a visually impaired African American singer and electric blues guitarist who was born in 1933. He has had a long recording career, being known as one of the best gospel guitars in the 1950s. Later, Drink Small's music branched out to include country, jazz, and dirty blues. Even though Drink Small now lives in Columbia, he is a regular artist at 145 Club. He can also be seen at festivals such as the New Orleans Jazz and Heritage Festival and the Julius Daniels Memorial Festival. (Author's collection.)

Susan Douglass Taylor
Susan Taylor is a well-known local singer and songwriter. A descendant of earlier settlers, she lives in Winnsboro. She studied under composer Nellie McMaster Sprott and learned to master the guitar and banjo at an early age. Taylor's music is a blend of bluegrass, country, folk, and gospel. She tours the South with several bands or as a solo performer and has recorded several CDs. (Courtesy of Virginia Schafer.)

LAURA GLENN DOUGLAS
AND HER ART

Laura Glenn Douglas (1886–1962)
This world-famous artist was born in Winnsboro, studied in New York and Paris, then settled in Washington, DC. After 1940, she confined her work to subjects of South Carolina. During one of her lectures, Laura stated, "The South has been sung in song, literature, prose, and poetry, but the portrayal of the South in painting has not been successfully done as yet. I seek to put the poetry and history of the South in paint, but with vigor and creativeness and not sentimentalism."

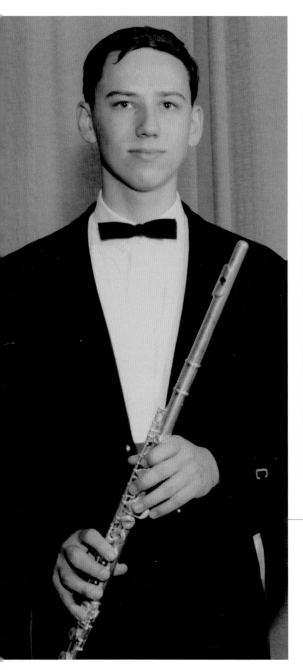

Nellie McMaster Sprott
This well-known and loved Fairfield County music teacher is recognized as the legendary songwriter who composed "Stand Tall for South Carolina," with some lyrics borrowed with permission from the state's poet laureate Archibald Rutledge. The song was written in 1969 to honor the state's tricentennial celebration and was later used as the theme song for the South Carolina Electric Cooperative Association. (Courtesy of the Sprott family.)

Tommy Sprott
Music was a big part of Winnsboro High School, especially in the early 1960s. Pictured here is Tommy Sprott, who played in the band under the direction of Walter Graham. Sprott is the son of well-known music teacher and composer Nellie McMaster Sprott. He is now a 6th circuit court judge.

Dru Blair
Dru is the director and founder of the Blair School of Art, which is located on a scenic, 100-acre campus that is part of his ancestral home place. After a career in art and illustration, Dru moved his school of art from North Carolina to the sleepy village of Blair in Fairfield County. His expertise in photograph realism has earned him accolades for his art. Dru specializes in airbrush art, especially with the focus on aviation and science fiction. The cover he did for an Air Force publication remains as one of the most popular pieces of art today. He was also chosen to be the official artist for the *Star Trek Voyager* book covers. His school is quite unique, not only because of its location, where tuition also includes room and board, but also for its high-tech interactive lectures on color, light, contrast, and the principals of photograph realism. Internationally known, Dru's art classes fill up quickly. One student praised him by saying, "One of the best weeks of my life (artistic and otherwise) was spent at the Blair School of Art." She added, "the workshop that he and his staff conducts every month is nothing less than extraordinary for any student of art." (Courtesy of Dru Blair.)

Pelham Spong

Pelham first knew she wanted to act at the age of six when her mother sang a song that included the words "They're gonna put ne in the movies," which resonated to her even at such a young age. She pursued her ambition at the College of Charleston, where she double majored in the performing arts and French. There, she was able to play a variety of roles including a rhinoceros, a prostitute with a heart, a Women Air Force Pilots (WASP) member, and Alice in *Closer*, which was part of the Piccolo Spoleto Festival 2007, an annual festival in Charleston, South Carolina. Hoping to combine her two loves, French and theater, she left the United States for Paris to study and perform. Pelham returned to the United States and resides in Charleston. She has recently been seen in the sold-out performances of *In Another Room*. Pelham is the daughter of Pelham Lyles and attorney T. Spong. (Courtesy of Pelham Lyles.)

CHAPTER SEVEN

Legends and Stories

No story of Fairfield County is complete without the urban legends and weird tales of the community. Some may be true, some false, and some maybe not so definitive. Fairfield County, with its vast historical reference, unique heritage, and presence of many still-standing buildings has a never-ending resource of stories. From witches and ghosts to royal heritage and buried treasure, the county is rich in storytelling. And now, with the new age of Internet, digitalization, and historical preservation, many people are researching not only their family history and stories but also facts and fallacies about local urban legends.

Some of the legends are tragic, such as the blinding of an Army soldier during his trip back home after his discharge from the service or the grog-drinking patrons who perhaps drank a corpse. Then, there are the heroic stories, such as a courageous cowboy who single-handedly killed more than 10 attacking bandits with his gun and knife-wielding expertise. Ghost sightings are often reported, especially across from Rock Creek Baptist Church. There are stories of moonshine raids—the biggest of which happened not in the 1930s but in 2012. Legends come from controversial stories like the claim that the great-great-grandson of the Lost Dauphin lived in Fairfield County. There was even a secret and illegal basketball game between Duke University and the North Carolina College for Negroes in the 1960s. The identities of the players have been lost, but some folks whisper that Fairfield principal Henry Simms played in the game. Other legends are about the conjoined twin girls who were hidden in Ridgeway during their kidnapping; they are possible descendants of Chang and Eng Bunker, the conjoined twins originally from Siam, for whom the name "Siamese twins" originates. The Bunkers, joined at the chest, settled nearby and produced 21 children between them. In Fairfield County, anything is possible.

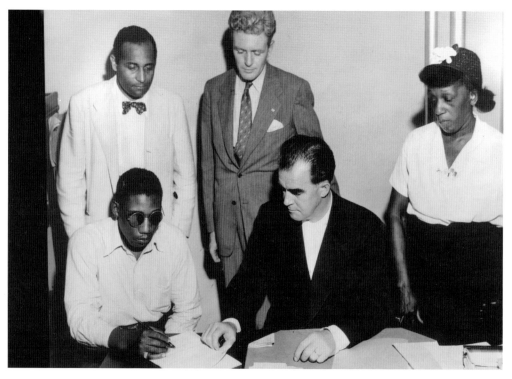

Sgt. Isaac Woodard (1919–1992)

Woodard was born in Winnsboro and joined the Army during World War II. He enlisted at nearby Fort Jackson in Columbia and was shipped overseas to the Pacific theater. It was there that he received several honors and awards. He was honorably discharged from the military at Fort Gordon, Georgia, and took a bus toward home; his family had since moved to North Carolina. During a stop in Batesburg, South Carolina, Sergeant Woodard—still in uniform—was taken off the bus. The driver had called police, saying he was irritated because Woodard had asked to use the restroom at a stop. Police officers took Woodard into an alley and beat him unmercifully, blinding him and giving him a concussion and partial amnesia. The story's details are not clear because of Woodard's memory loss. The officers claimed that Woodard was drinking on the bus and resisted arrest. Woodard later said, with witness collaboration, that there was no confrontation, and he was hit several times and then was jabbed in the eyes with a billy club. Both of his corneas were completely severed. Woodard was taken in front of a judge the next morning and fined $50. The young man asked for medical care but did not receive any for two days. Still suffering from amnesia, Woodard landed in a substandard hospital. After three weeks of waiting, his relatives contacted authorities for a report on their missing kin. When found, he was rushed to a Spartanburg hospital, but it was too late to save his eyes. The NAACP and other organizations gathered with the media to publicize this incident, while the state of South Carolina did what it could to dismiss the case. Famous artists came to crusade for Woodard; radio shows hosts, including Orson Welles, talked about the incident; Woody Guthrie wrote and performed songs such as "The Blinding of Isaac Woodard;" and artist Lord Invader wrote and performed antiracial songs like "God Made Us All" in support of Woodard. In 1946, the federal government became involved and proceeded to prosecute Sherriff Shull, of Batesville-Leesville, and his accomplices. However, even though there were antiracial comments during the trial, Shull was found not guilty on all charges—a shock since Shull admitted in the courtroom that he blinded Woodard. There was only a 30-minute deliberation. Shull lived on comfortably in his hometown and died at the ripe old age of 95. Woodard moved north and died in the Bronx, New York, at the age of 73. In July 1948, over the objection of senior military officers, President Truman promulgated Executive Order 9981, banning racial discrimination in the armed forces. (Author's collection.)

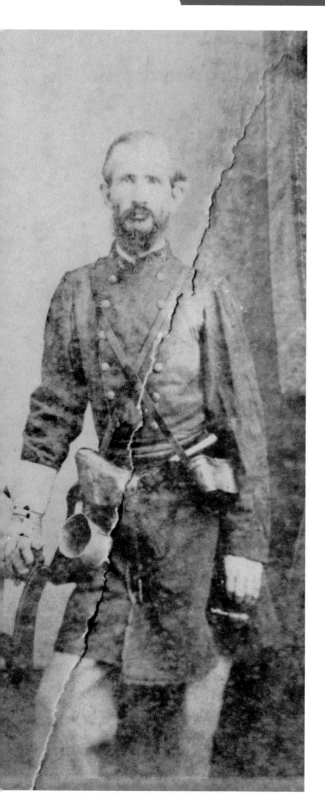

The Lost Dauphin

The Lost Dauphin story is an enigma about the son of King Louis XVI of France. The unanswered question is whether or not the boy was imprisoned and died in the Temple prison in Paris in 1795. Some claim the Lost Dauphin had escaped or was not the same boy at all, especially since the servants sent to identify the body had never seen the King's son. Some believe that the Lost Dauphin went on to live under an assumed name. On his deathbed, Col. James Henry Rion, a plantation owner and lawyer from Winnsboro, did just this. The year was 1886 and Rion armed with "evidence"—letters and personal articles from France in the late 1700s—declared that his father was in fact the Lost Dauphin. The story is that Marie Antoinette's personal guardian, Ambassador Mercy-Argenteau, snuck the young boy, Antoinette's son, out of France and into England dressed as a girl. In England, the ambassador died and the child was handed over to a Dr. Hunter, the private physician to the Prince of Wales. Charlotte Renaud De La Hav De Rion was hired to pose as the mother. The child—named Henry Rion—and his new family moved to Canada. Henry Rion grew up, joined the military and married Margaret Hunter, a relation to his guardian. Major Rion, unfortunately, never got to see his son James Henry Rion, who was born 10 days after he died. Margaret Hunter Rion and her son moved to Savannah, Georgia, where she met James C. Calhoun, who mentored young Henry and brought both of them to South Carolina. The Rions became one of the most important families in Fairfield County. Still today, because of Colonel Rion's deathbed confession and the "evidence" housed at the Florida Museum, the Rions are the object of gossip regarding the identity of the Lost Dauphin. (Courtesy of James Gabel.)

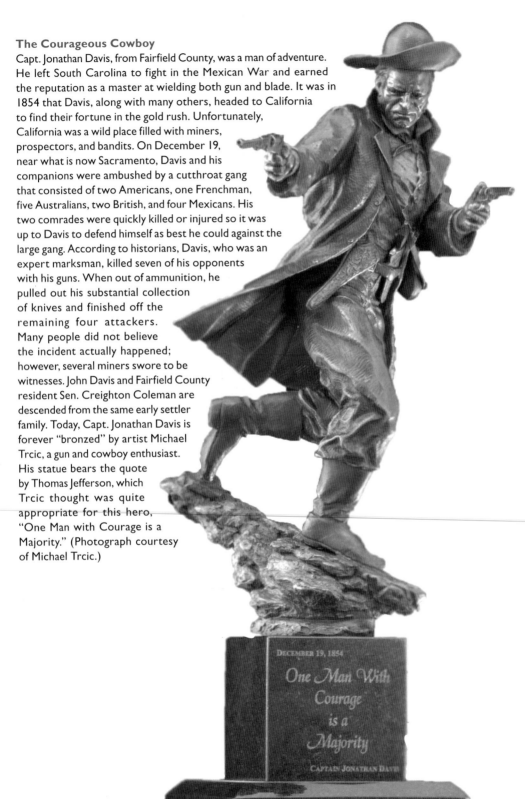

The Courageous Cowboy

Capt. Jonathan Davis, from Fairfield County, was a man of adventure. He left South Carolina to fight in the Mexican War and earned the reputation as a master at wielding both gun and blade. It was in 1854 that Davis, along with many others, headed to California to find their fortune in the gold rush. Unfortunately, California was a wild place filled with miners, prospectors, and bandits. On December 19, near what is now Sacramento, Davis and his companions were ambushed by a cutthroat gang that consisted of two Americans, one Frenchman, five Australians, two British, and four Mexicans. His two comrades were quickly killed or injured so it was up to Davis to defend himself as best he could against the large gang. According to historians, Davis, who was an expert marksman, killed seven of his opponents with his guns. When out of ammunition, he pulled out his substantial collection of knives and finished off the remaining four attackers. Many people did not believe the incident actually happened; however, several miners swore to be witnesses. John Davis and Fairfield County resident Sen. Creighton Coleman are descended from the same early settler family. Today, Capt. Jonathan Davis is forever "bronzed" by artist Michael Trcic, a gun and cowboy enthusiast. His statue bears the quote by Thomas Jefferson, which Trcic thought was quite appropriate for this hero, "One Man with Courage is a Majority." (Photograph courtesy of Michael Trcic.)

DECEMBER 19, 1854

One Man With Courage is a Majority

CAPTAIN JONATHAN DAVIS

Gen. Michael Edward Pakenham (1778–1815)

General Pakenham was a well-known politician and military figure. At age 16, his wealthy royal family purchased his commission as lieutenant in the 92nd Regiment of Foot and, between 1799 and 1800, he represented Longford Borough at the Irish House of Commons. His sister Catherine married Arthur Wellesley, the duke of Wellington, thus making the duke his brother-in-law. Pakenham fought in many battles worldwide, from his home in Ireland to Nova Scotia, Barbardos, St. Lucia, and Copenhagen. He commanded a regiment in 1810–1811 and joined his brother-in-law in the Peninsula War during the Napoleonic Wars. In 1814, he replaced Gen. Robert Ross, commander of the British North American army. Ross was mortally wounded in battle. Only a year later, at the Battle of New Orleans, General Pakenham was wounded in the knee, then his horse was shot out from underneath him. As he was assisted back to camp, he was mortally wounded and died on the battlefield at age 36. Above is a famous painting of the battle and General Pakenham's demise. It was custom at that time to "embalm" officers in barrels of rum for safe travels back home to be buried. As the story goes, General Pakenham never made it back to the British Isles but was mistakenly transported to Charleston, South Carolina, where a delivery of rum was being made to local taverns. The supposed Pakenham barrel made it to a pub in Fairfield County and was consumed by merrymakers during a Christmas holiday party. After the barrel was empty of drink, consumers discovered something else in the barrel—something that was later identified as General Pakenham based on his uniform and personal affects. What remained of the body was said to have been buried in an unmarked grave not too far from the tavern. The incident probably made many men swear off drinking or at least drinking out of a barrel. (Courtesy of PDMP Gallery.)

Margaret McMaster

McMaster, a prominent citizen and beauty queen from Winnsboro, is the great-great granddaughter of one of the original "Siamese twins" later known as Chang Bunker. The twins were born in Thailand, formerly Siam. The Bunkers are how the term "Siamese twins" originated. The twins were joined at the chest by a small piece of cartilage but their livers were fused. The organs were independently functional, but during the early 19th century, surgery was not possible. The twins were discovered by a British merchant and were exhibited worldwide in sideshows and circuses. When their contract ended, the twins became naturalized citizens, retired to a plantation in North Carolina, and adopted the name "Bunker." The Bunkers worked at a grocery store and farmed a 110-acre plantation; they even purchased slaves. The Bunkers married sisters on April 13, 1843, and had 21 children between them. Their beds were specially built to hold four people. The twins shared time between their two houses with specific scheduling. The wives did not always get along, but the children did. The children were double first cousins and also half sibling who are first cousins. Chang died in his sleep in January 1874. Eng had summoned the doctor to perform an emergency surgery but the doctor was too late. Eng died shortly after his twin. The Bunkers raised proud and ambitious children. Their descendants, who also include several sets of non-conjoined twins, number over 1,500. Many stayed in the North and South Carolina area. The McMasters of Fairfield County, a prominent clan and one of the backbone families of Fairfield County, were part of the Bunker family. They donated some of Chang Bunker's possessions to the Wilson Library in North Carolina. Linda Jacobson, curator of the library's North Carolina Collection Gallery said, "These latest donations help remind us that these legendary figures were real people."

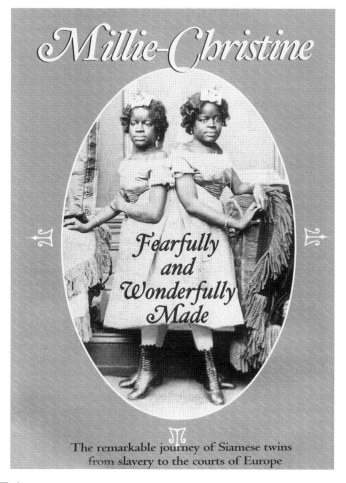

Millie-Christine

Fearfully and Wonderfully Made

The remarkable journey of Siamese twins from slavery to the courts of Europe

The Carolina Twins

The conjoined "Carolina Twins," Millie and Christine, were African Americans born into slavery in 1857. They belonged to Jabe McCoy, then John C. Purvis, and were later given to showman Joseph P. Smith to pay off a $200 debt. The Smith family moved from North Carolina to Spartanburg, South Carolina, so the businessman's children could be educated at Wofford College. The Smiths were very proud of Millie and Christine; they walked sideways, were very educated, and sang like nightingales. One was soprano and the other alto, and they often sang duets. They were sometimes exhibited in the Barnum's American Museum under the stage name the "Two-Headed Nightingale" or "The Eighth Wonder of the World." Their life was very exciting. The pair was always known to be in great humor and often played music, sang, and danced. Their excitement continued when they were kidnapped by a rival showman and shipped to England where they performed for Queen Victoria and were given expensive gifts. However, since England had outlawed slavery, the twins were given back to their mother, whom Smith had brought with him to England, and they all returned to South Carolina. During their travel, they were regularly hidden in the town of Ridgeway. A book was written and published in the mid-1800s called *The History of the Carolina Twins: Told in their Own Particular by One of Them*. Millie and Christine, who were making more than $600 a week during their performing days, donated much of their funds to black schools and churches in North and South Carolina. When Millie was diagnosed with tuberculosis, doctors thought about surgery to perhaps save the healthy sister, but, instead, when Millie died in October 1912, doctors decided to give Christine morphine to help end her life quickly. Christine lived another 17 hours and finally joined her sister once again. (Author's collection.)

Col. David Provence

Col. David Provence was an eccentric man originally from Kentucky, but after serving in the Mexican War and Civil War, he lived in Ocala, Florida, where he worked as an attorney and was elected to the Senate. It is here he fell in love with Elizabeth Hall from Fairfield County and came to live in Rose Hill, Elizabeth's home place, in Struthers, South Carolina. This area, not too far from Blair in Fairfield County, provided Provence with farmland, and he became a plantation owner and farmer. The homestead had been saved from destruction, rumors have it, when the Elizabeth, as a girl, was asked to play "Yankee Doodle" on the piano by an invading General Sherman officer. Instead, Elizabeth played "Dixie," and the officer stopped the demolition of the house claiming, "This young lady was a strong woman." Colonel Provence died merely 10 or so years after his military service. The war experiences had exacerbated his respiratory illness, and pneumonia finally took him in 1874. His grave, located across the street from Rock Creek Baptist Church, was quite controversial. Some say that he did not want to be buried in the church cemetery because he was Catholic; others say that he did not want to be with "the common herd." William Haynesworth Lyles, his neighbor, claimed that the colonel wanted to be "safe" and not have his remains plowed under or desecrated. The colonel's fears came true when a group of Italian stones cutters, who were brought in to work in the prosperous granite quarries, heard rumors that Provence was buried with a fortune. They exhumed the body and left the mummified corpse upright beside the grave. Neighbors and the Provences' sharecroppers, the Peoples, came upon the scene and thought the colonel had escaped his grave since his body was standing up. Rumors say that his spirit haunts the house and road leading to the grave. The grave marker still stands atop the lonely hill in Fairfield County.

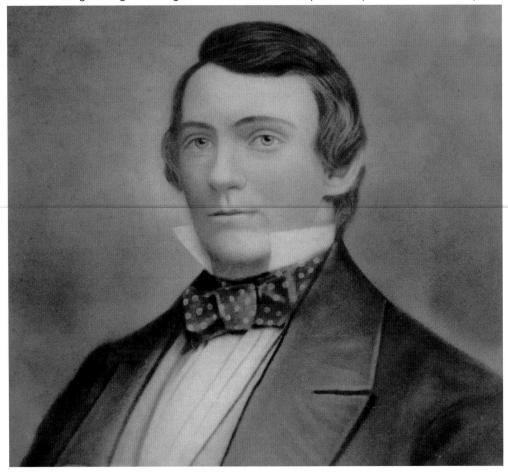

Coach Henry Sims

In 1944, during the time of Jim Crow laws in the South, a secret basketball game was played between the Eagles, the winning black basketball team from the North Carolina College for Negroes in Durham and the Blue Devils from Duke University, the South Conference Championship winners at that time. Any integrated sports team or game was illegal at that time. It was a challenge from North Carolina coach John McClendon that gave Duke a nudge. Duke coach David Hubble hesitated briefly but finally accepted the challenge. After a clandestine journey to North Carolina College's old brick gym, the game began. They played nervously at first, as most of these men had never played against a player of a different color. The Eagles won that day, with only the two teams and a referee in attendance. The score was 88-44. This was the first known integrated basketball game in the South. The Duke players left, and for 52 years, the game remained a secret. The racial tensions were high during that time, and even though some believed segregation was wrong, it was the law. The meeting remained publicly unknown for more than 52 years, until Scott Ellsworth, a Duke University graduate and historian, wrote an article about the historical event that appeared in the *New York Times* on Sunday, March 31, 1996. "The Secret Game" was born. Coach Henry Sims, former principal at Fairfield Junior High School, was enrolled at North Carolina College for Negroes during this time. It was rumored that he was a participant in the secret game. In this photograph are, from left to right, Dr. Tom Thompson, former principal at Winnsboro High School in the late 1980s and superintendent in the school district; art teacher Robert Kinard; and Henry Sims, former principal at Fairfield Junior High.

Fairfield County Moonshine

In this picture, law enforcement officers raid a moonshine still in Fairfield County. Shown are, from left to right, two unidentified people, Woodward Hollis, Deputy Sheriff Jack Robinson, and David Robert Boulware in the 1950s. The story goes that there was a raid on the Pines Nightclub in Simpson area of Fairfield County. The still's owner and his helper had busted the jars of moonshine on the floor, and one of the deputies took off his shirt and was trying to mop it up. The sheriff wanted to know what he was doing, and the deputy said he was trying to save the evidence. The sheriff asked him, "What the hell you going to put it in if all the jars are gone?" Recently, Fairfield County deputies made one of the biggest moonshine busts in the history of the county. During a sting for drugs, Drug Enforcement Administration agents, with the help of local authorities, came upon a major moonshine operation. The illegal liquor, which included almost 30 gallons, was made with local fruits. Sheriff Herman Young said the scene was very unsanitary, big, and dirty. "We saw bugs inside one of the four 55-gallon stills and a mouse crawling out of another one. We thought we did not have anymore (moonshine stills)," Young told WIS News 10. Young says the last time moonshine was found in the county was five years ago. The legends of moonshine are still alive in Fairfield County.

The Fairfield County Historical Museum

The Fairfield County Historical Museum is located in downtown Winnsboro, just a few blocks from the historic town clock. In 1930, Richard Cathcart built the structure, which is also in the historic registry, so he and his family could enjoy the city life, away from his cotton plantation. Then, Catharine Ladd and her artist husband purchased the structure in 1848. It was here that she conducted her school for young ladies, off and on, until shortly after the Civil War. The building went through several buyers until 1976, when the City of Winnsboro purchased it for the museum's new home. The museum has several floors of exhibits and also houses the Fairfield County Genealogical Society section on the second floor. Volunteers are often available to assist family researchers with the collected paper files, published volumes, microfilm records, and computer software. The collection is available during museum visitation hours on Tuesdays through Saturdays. For more information about the Fairfield County Historical Museum, the Fairfield Historical Society, and the Fairfield County Genealogical Society, contact Pelham Lyles at (803) 635-9811. Shown above, the Fairfield County Genealogical Society meets for a special training on ancestry research with Tally Johnson, the Chester County Library special services coordinator. Shown are (first row) Dot Cooper, Sarah T. Sexton, Sherry Cashwell, Pelham Lyles, Janice Cain, Mary Ann Hollis, Frances Lee O'Neal, and Benjamin Hornsby Jr.; (second row) Edward Lee Killian Jr. and Linda S. Frazier; (third row) Tally Walker and James W. Green III. (Author's collection.)

INDEX

LEGENDARY
LOCALS

AN IMPRINT OF ARCADIA PUBLISHING

Find more books like this at
www.legendarylocals.com

Discover more local and regional history books at
www.arcadiapublishing.com